THE FASHION DESIGN WORKBOOK

Fashion Drawing and
Illustration Workbook with
14 Fab Fashion Styles

Annabel Bénilan

David and Charles

www.stitchcraftcreate.co.uk

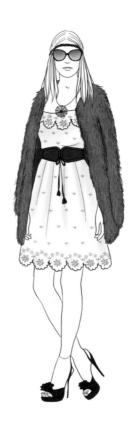

To my goddaughter Adèle

With thanks to Colette,
Corinne and Violette

'Fashion changes, but style endures'

Coco Chanel

We all know a piece of music that can move us, a place where we feel completely at home, a colour we like, an ideology that we believe in or a culture we love. In short, there is a whole range of things that shape our personality and our world, influencing our taste in clothing and defining our style.

Fashion design is created from a context, a movement or a specific philosophy of life.

The way we dress has a history; the colour ranges and patterns have meaning and the fabrics are symbolic.

Fashion designers take inspiration from all these elements to create their collections – reinterpreting, personalizing and mixing them as they see fit.

This book looks at the most well-known fashion styles of the past and present, while also teaching you how to draw the fashion figures, clothes, fabrics and prints.

Everyone has their own style, so get your pencils out and find yours!

Annabel Bénilan

Contents

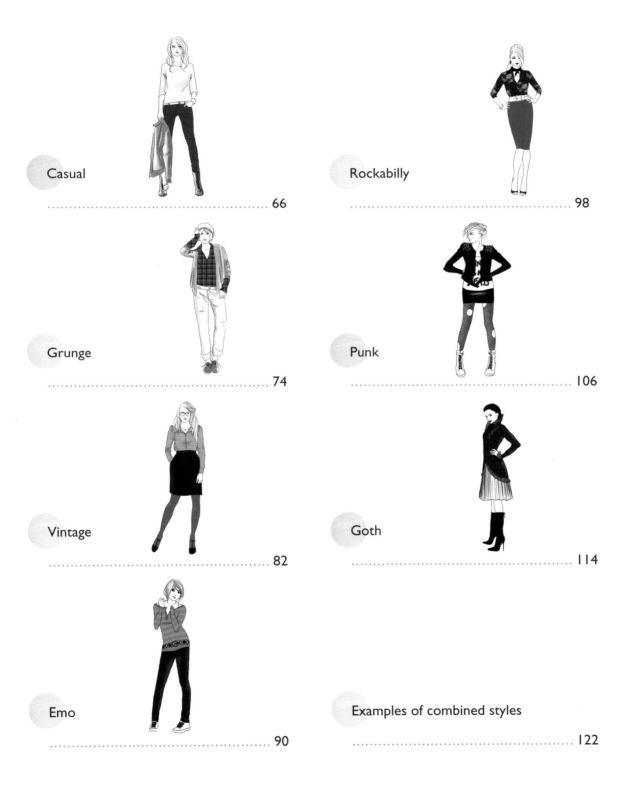

HOW TO DRAW A FASHION FIGURE

1. Divide the body into 8 equal parts (the fashion figure measures 8 times the size of its head). Mark the lines of the skeleton using a pencil.
2. The joints should be marked in pencil with a ball shape.

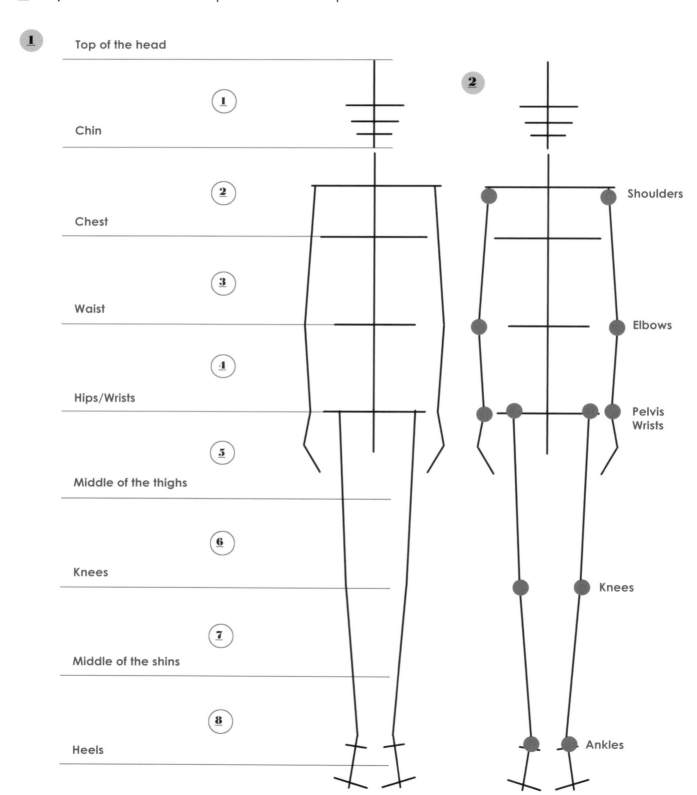

1 Top of the head

①

Chin

②

Chest

③

Waist

④

Hips/Wrists

⑤

Middle of the thighs

⑥

Knees

⑦

Middle of the shins

⑧

Heels

2

Shoulders

Elbows

Pelvis
Wrists

Knees

Ankles

3. Using a pencil, draw around the lines to start giving the figure shape. Draw an egg shape for the head and cylinder shapes for the other parts of the body.

4. Draw the curves of the body around these cylinders and joints. Draw the shapes of the eyes, nose and mouth along the lines of the face.

5. Go over this overall shape with a fine pen and erase the pencil marks (see diagram 5).

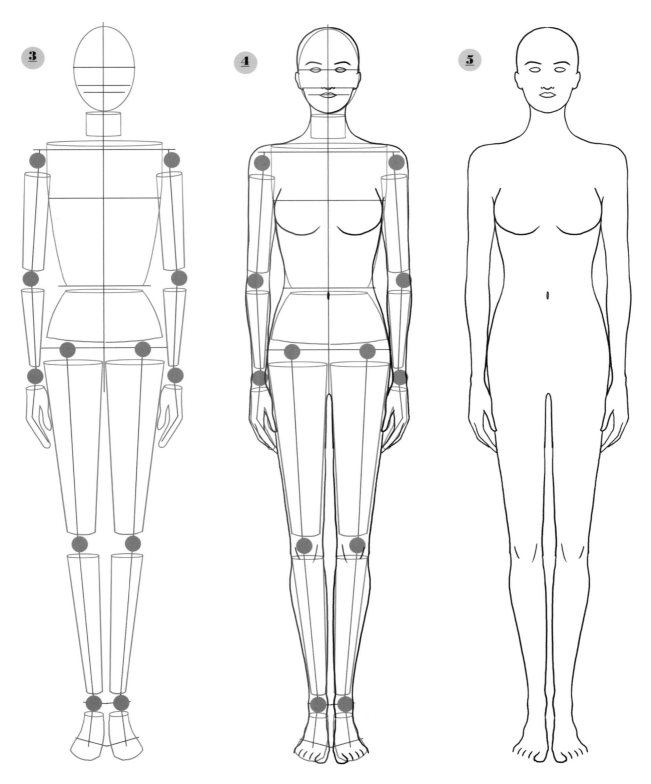

HOW TO BRING THE FASHION FIGURE TO LIFE
AND CREATE DIFFERENT POSES

1. Rearrange the balls for the joints, linking them with lines, but keeping the same proportions as before.

2. Using a pencil, draw around the lines to start giving the figure shape. Draw an egg shape for the head and cylinder shapes for the other parts of the body.

3. Draw curves and facial features.

4. Go over this overall shape with a fine pen.

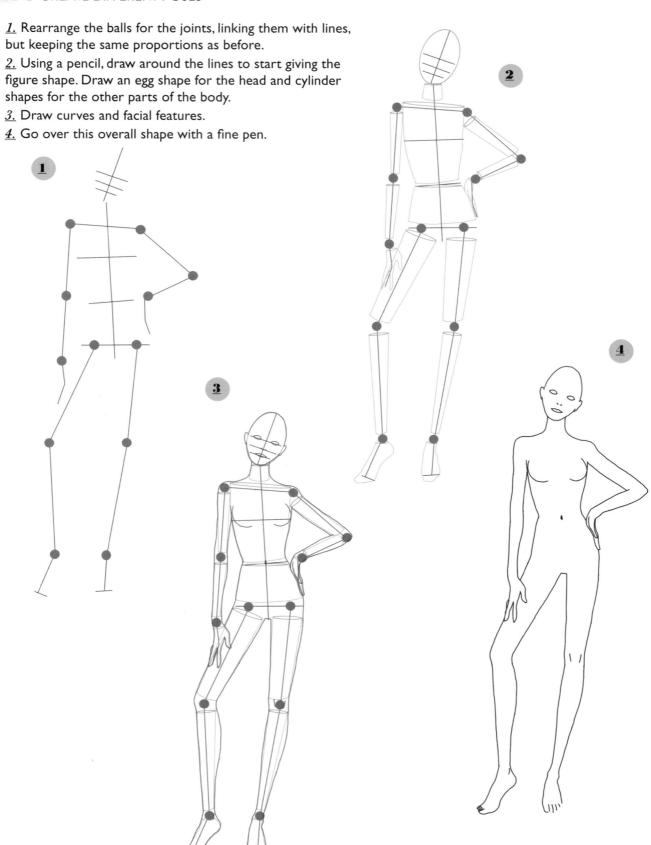

You can create lots of different poses using this technique.
Get inspired by models in magazines, ask a friend to pose for
you or have fun posing yourself in front of the mirror.

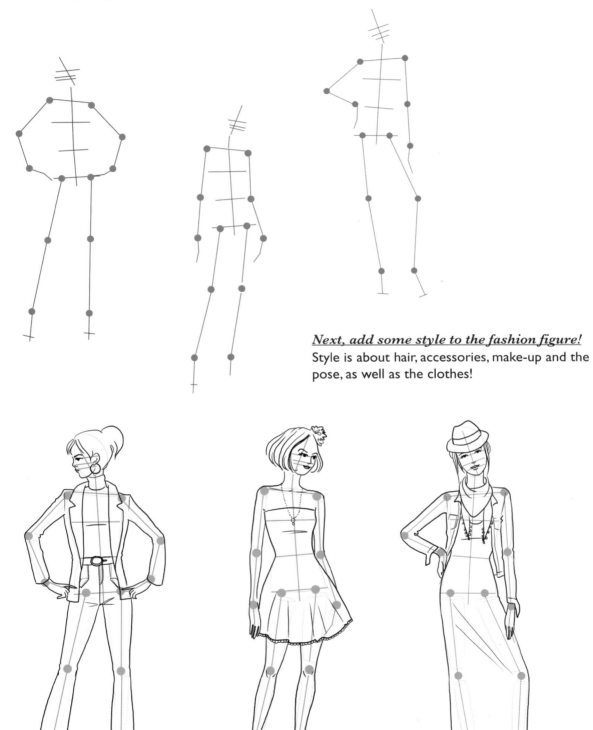

Next, add some style to the fashion figure!
Style is about hair, accessories, make-up and the
pose, as well as the clothes!

Bohemian

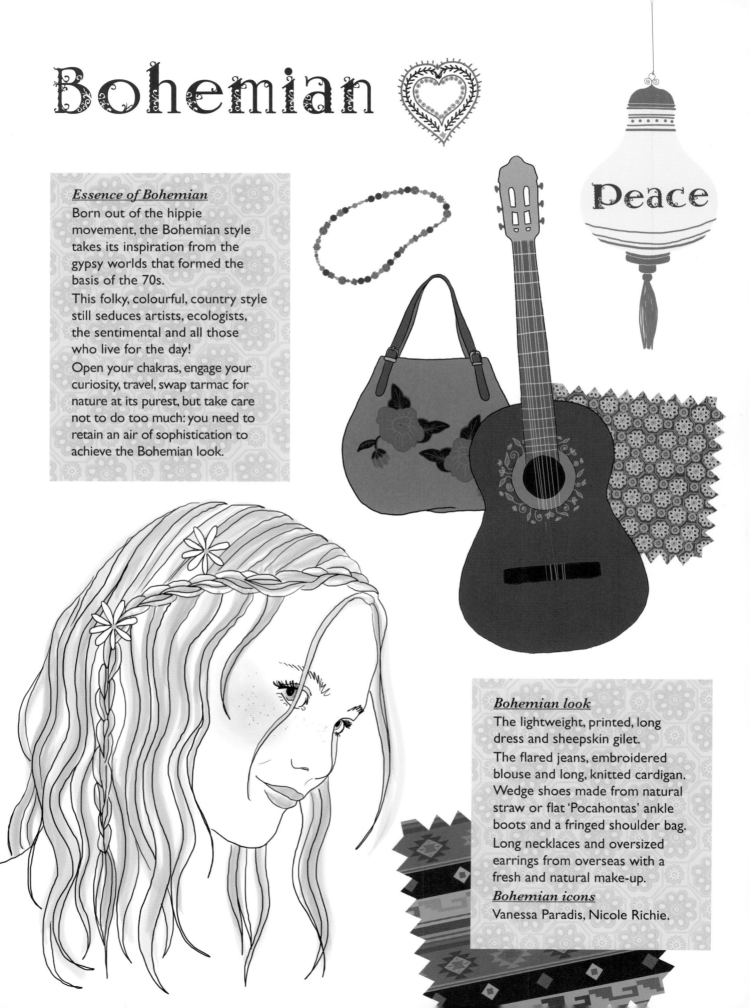

Peace

Essence of Bohemian

Born out of the hippie movement, the Bohemian style takes its inspiration from the gypsy worlds that formed the basis of the 70s.

This folky, colourful, country style still seduces artists, ecologists, the sentimental and all those who live for the day!

Open your chakras, engage your curiosity, travel, swap tarmac for nature at its purest, but take care not to do too much: you need to retain an air of sophistication to achieve the Bohemian look.

Bohemian look

The lightweight, printed, long dress and sheepskin gilet.
The flared jeans, embroidered blouse and long, knitted cardigan.
Wedge shoes made from natural straw or flat 'Pocahontas' ankle boots and a fringed shoulder bag.
Long necklaces and oversized earrings from overseas with a fresh and natural make-up.

Bohemian icons

Vanessa Paradis, Nicole Richie.

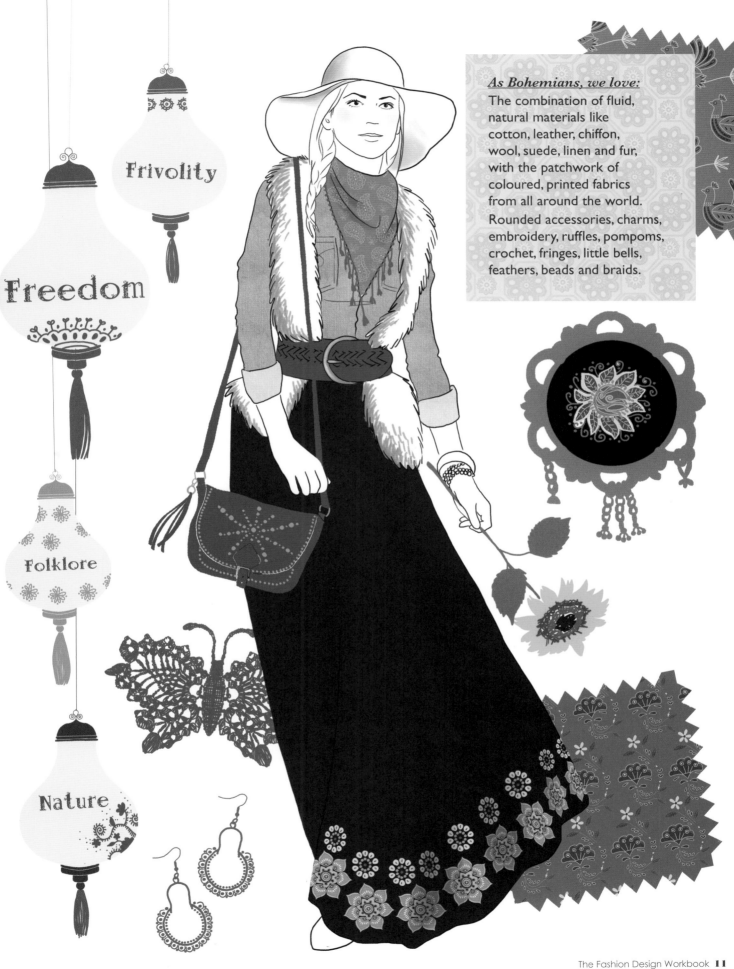

Frivolity

Freedom

Folklore

Nature

As Bohemians, we love:
The combination of fluid, natural materials like cotton, leather, chiffon, wool, suede, linen and fur, with the patchwork of coloured, printed fabrics from all around the world. Rounded accessories, charms, embroidery, ruffles, pompoms, crochet, fringes, little bells, feathers, beads and braids.

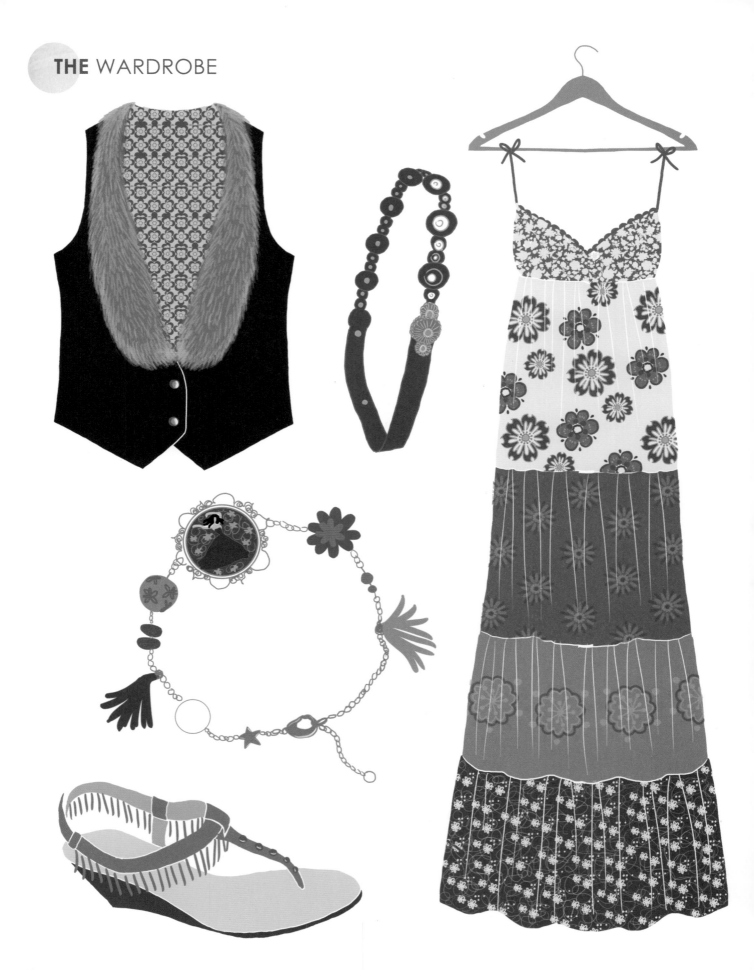

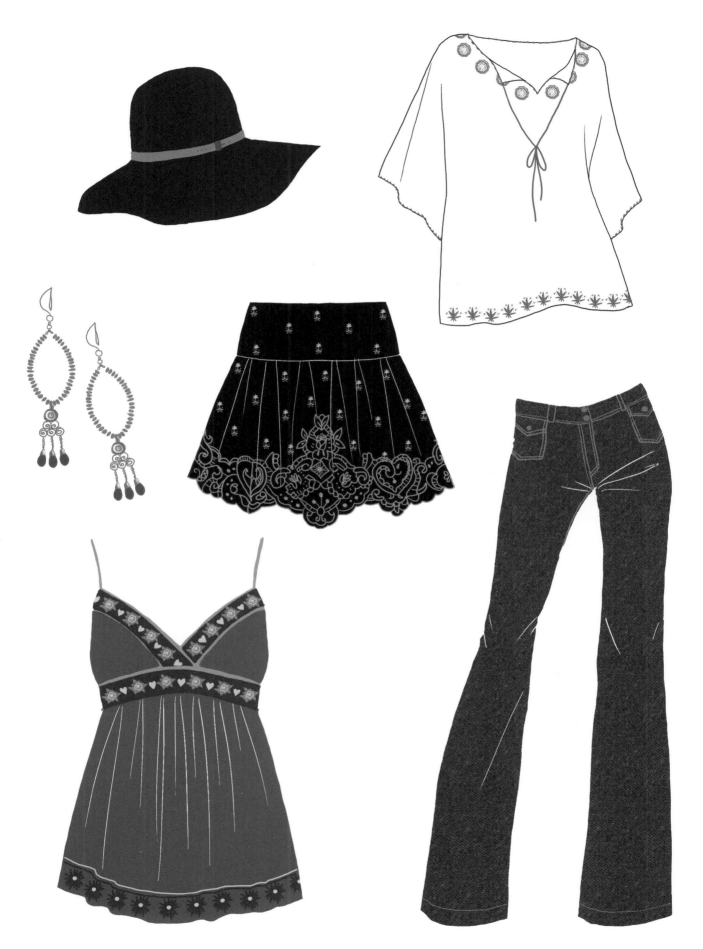

PATTERNS, FABRICS & TECHNIQUES

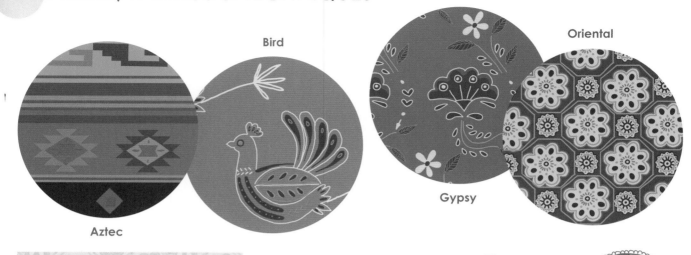

Aztec

Bird

Gypsy

Oriental

Paisley pattern

1. Draw a droplet with a felt tip or pencil.

2. Draw a larger drop around it.

3. Draw an even larger drop around it and curl the end around.

4. Apply the desired colours and decorations using paint, felt tip or ink.

Denim

1. Apply the base colour of a denim-like blue, using paint, ink or felt tip.

2. Then use a white pencil to colour diagonally from left to right.

3. Colour diagonally on top, colouring from right to left.

Fur

1. Apply the base colour in shades of brown using paint, felt tip or ink.

2. Once it is dry, draw short lines (hatch) using beige ink, paint or felt tip to depict the first layer of fur.

3. Hatch again once it has dried, using ink, paint or felt tip in shades of pale yellow for the second layer of hair.

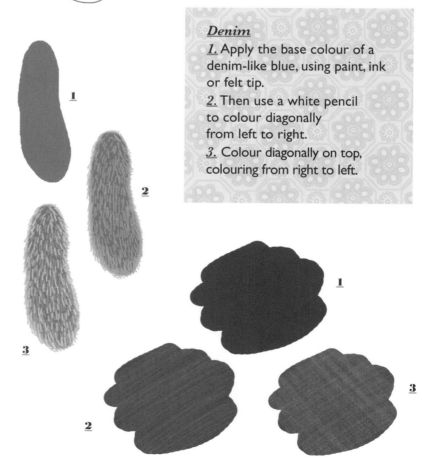

Paisleys to colour in and decorate

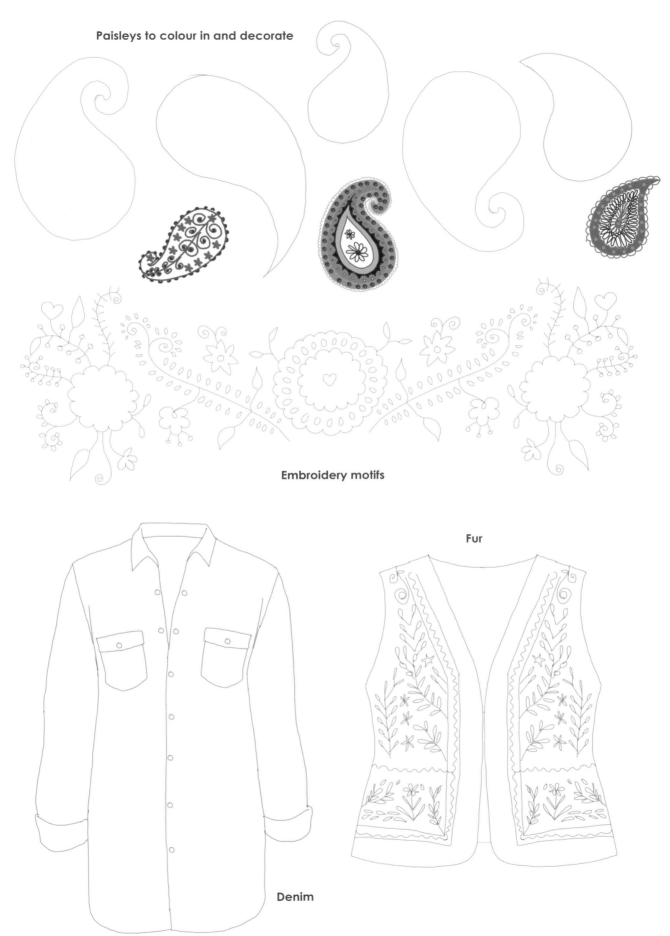

Embroidery motifs

Fur

Denim

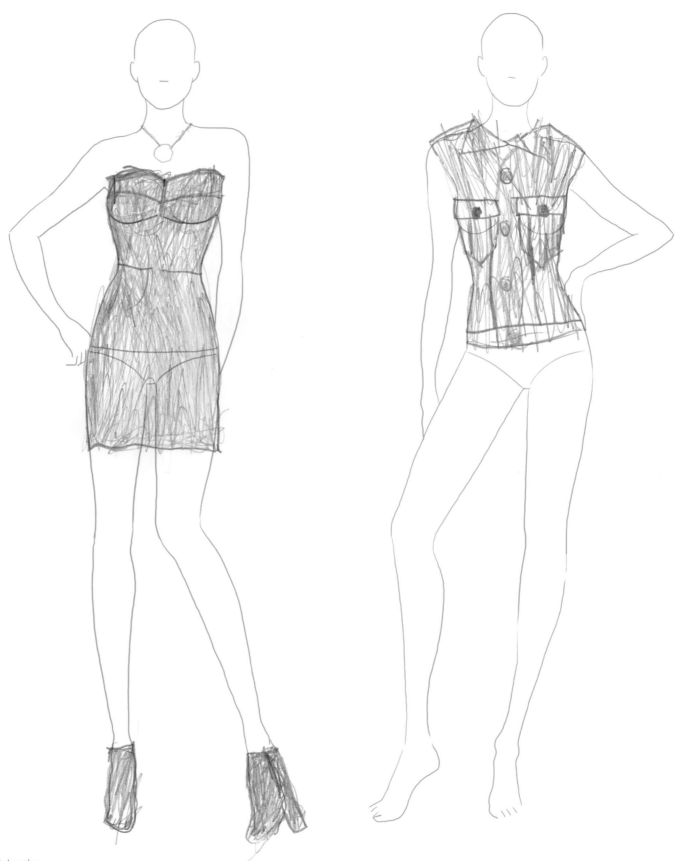

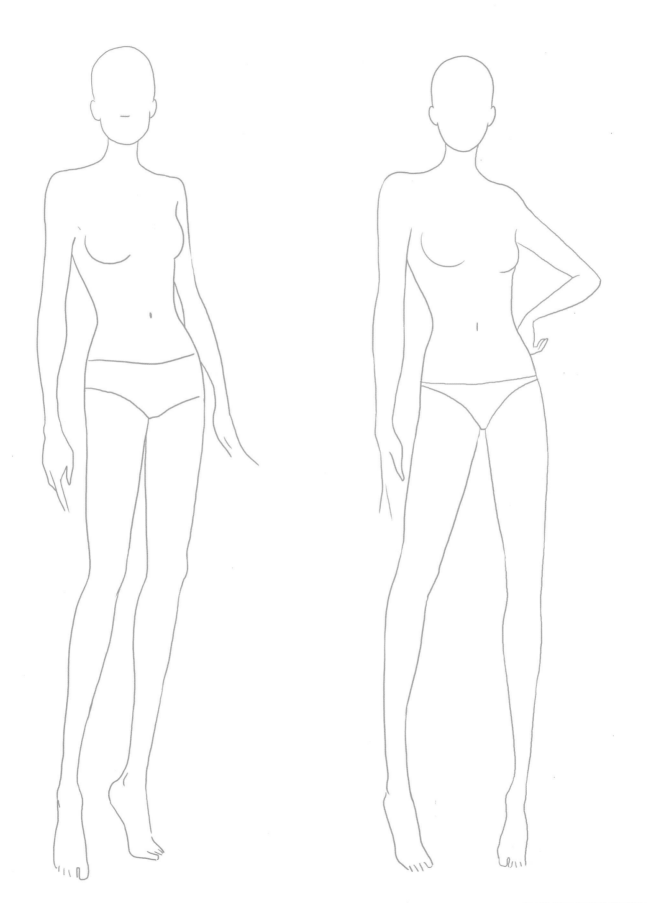

ROCK CHICK

Essence of a rock chick

Rock chick fashion started in the 50s when the first rock bands from the US appeared, styled in leather jackets, turned up jeans and biker boots. Even today, the rocker spirit continues to shake up fashion codes and traditions. Characterized by the powerful sounds of famous guitarists, it established itself as a real fashion phenomenon.

It's not for the faint-hearted! To be a rock chick, you need to have a rebellious spirit and carry it off in style!

Rock chick look

A zipped leather jacket over drainpipe jeans and a studded belt.

A sleeveless T-shirt printed with an anarchic slogan.

A very large bag or a clutch bag, a fringed scarf, high heels or biker boots.

Statement jewellery.

Rock chick icons

Kate Moss, Taylor Momsen, Kirsten Stewart.

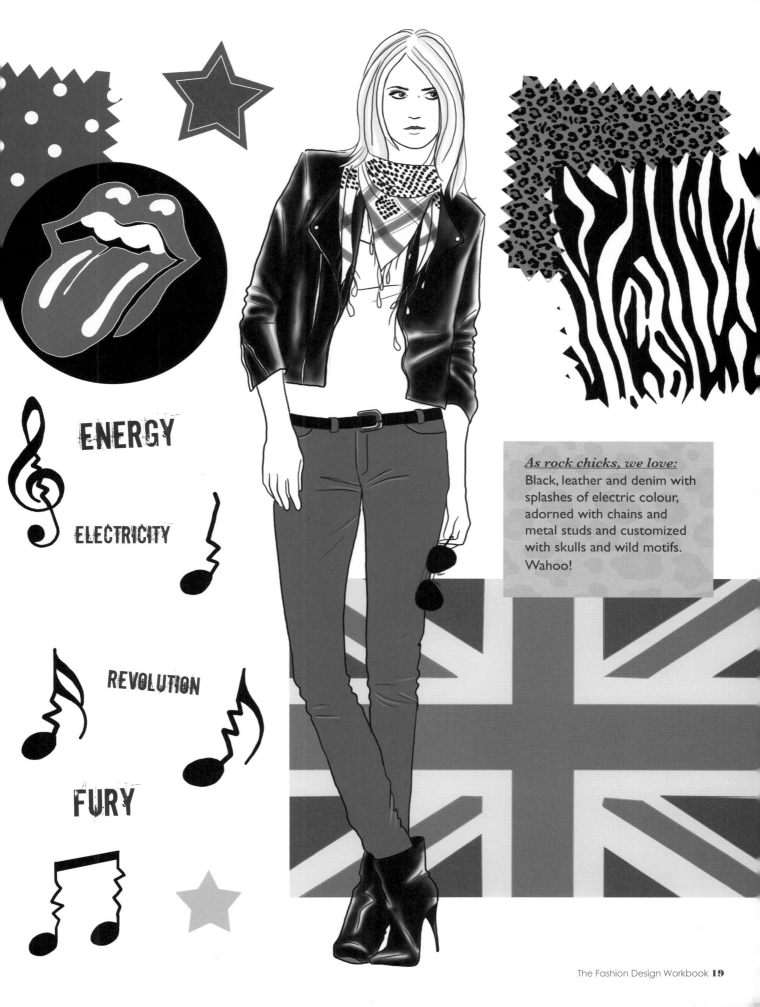

ENERGY

ELECTRICITY

REVOLUTION

FURY

As rock chicks, we love: Black, leather and denim with splashes of electric colour, adorned with chains and metal studs and customized with skulls and wild motifs. Wahoo!

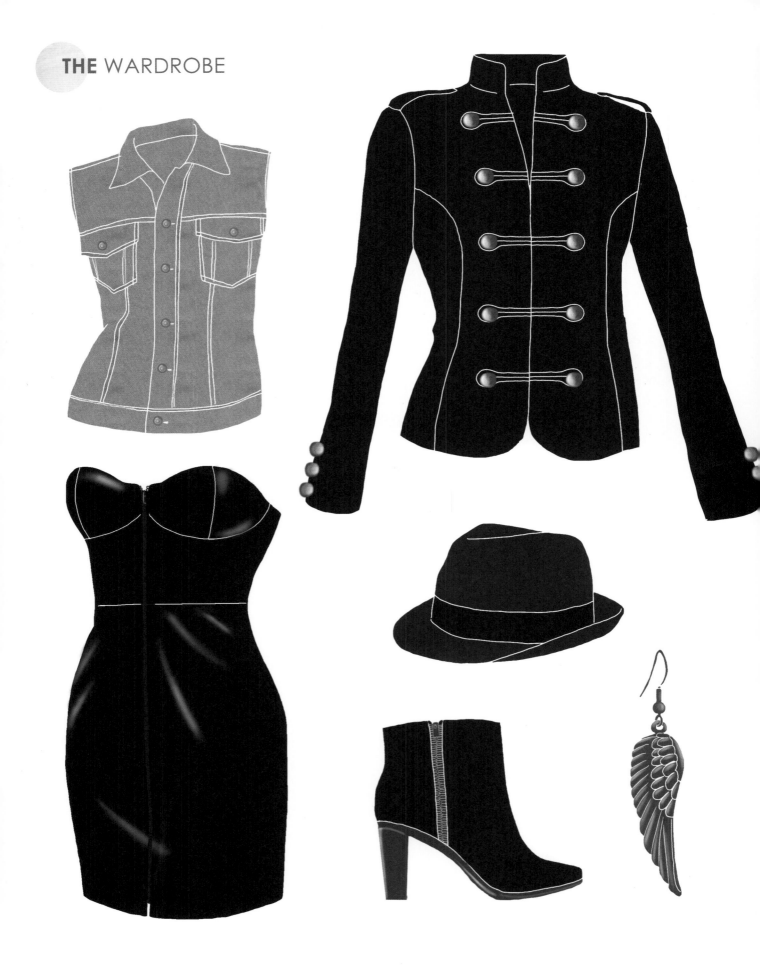

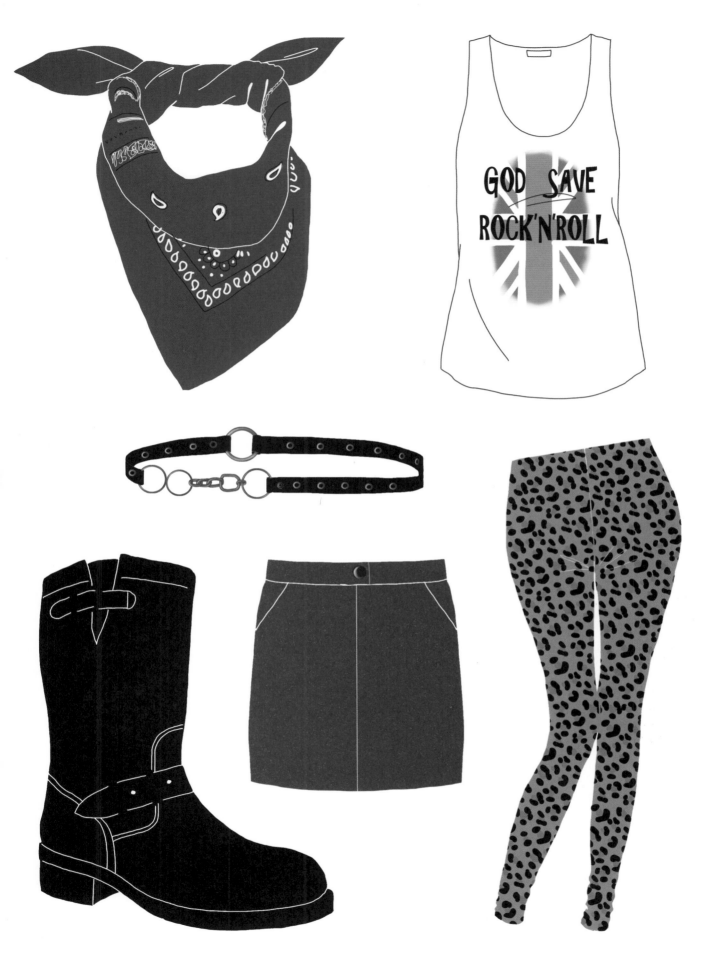

GOD SAVE ROCK'N'ROLL

PATTERNS, FABRICS & TECHNIQUES

Skulls

Leopard

60s

Zebra

Leather
1. Fill in your design with a felt tip or black paint.
2. Apply white pastel to highlight and give a more 3D look.
Smudge the pastel highlights with your finger.

Leather and metal

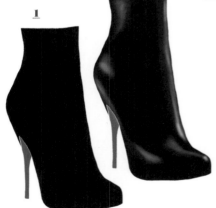

1

2

Metal
1. Draw a dark grey ring using paint, felt tip or a coloured pencil.
2. Draw other rings linked together.
3. Apply some white pastel to the rings to create a 3D effect and the reflections in the metal. Smudge with your finger.

Pyramid studs
1. Draw the outlines of the pyramid using a pencil.
2. Using paint or a coloured pencil, fill in the four sides of the design shading from grey to white to create a 3D effect and reflections in the metal.

1

White

Light grey

2

Dark grey

 1

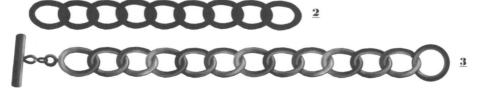

2

3

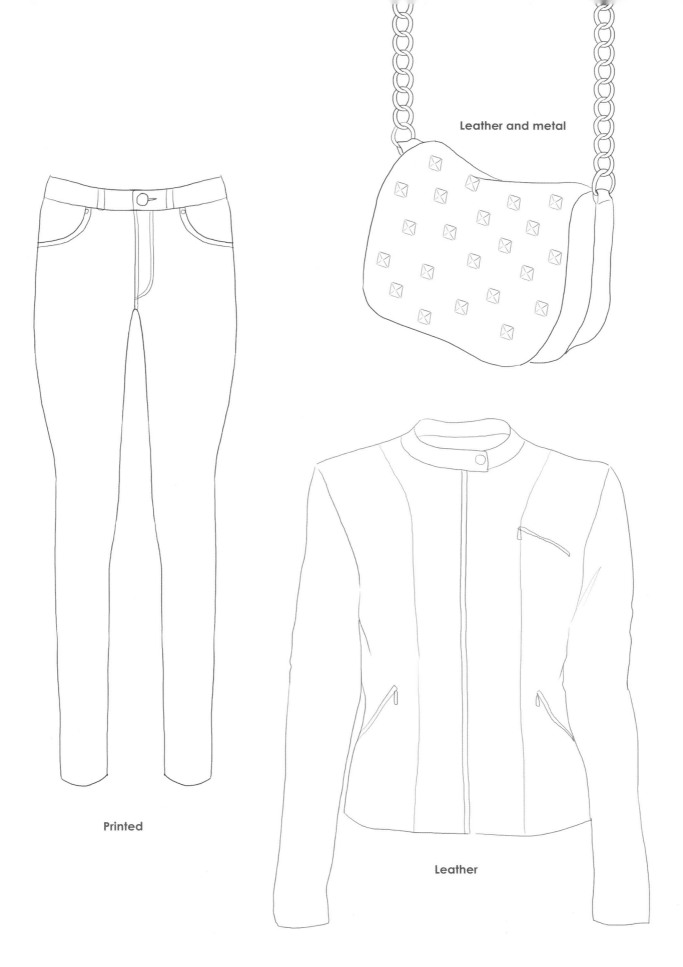

Leather and metal

Printed

Leather

ROCK CHICK FASHION FIGURES
TO DRESS AND ACCESSORIZE

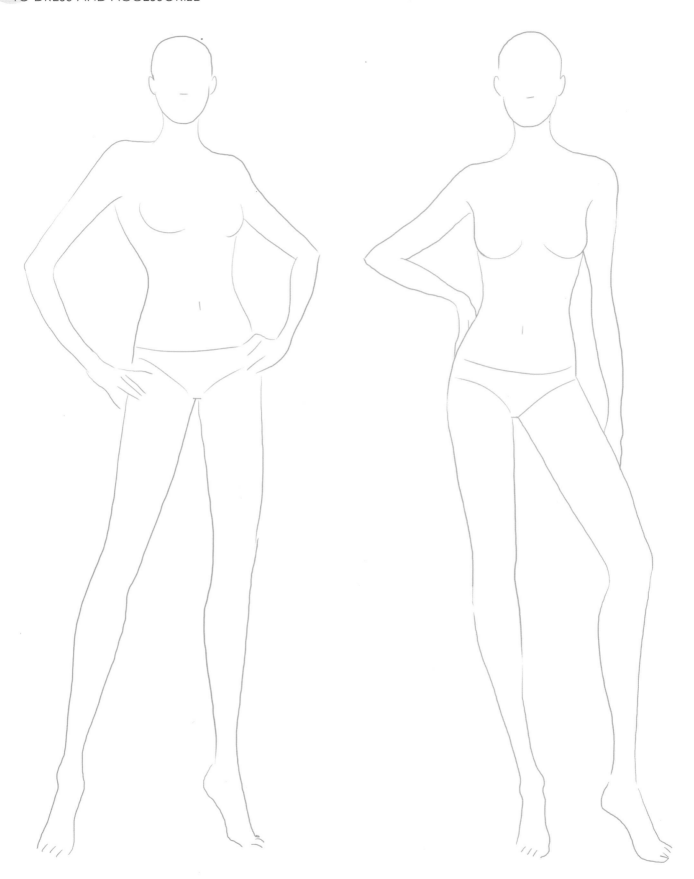

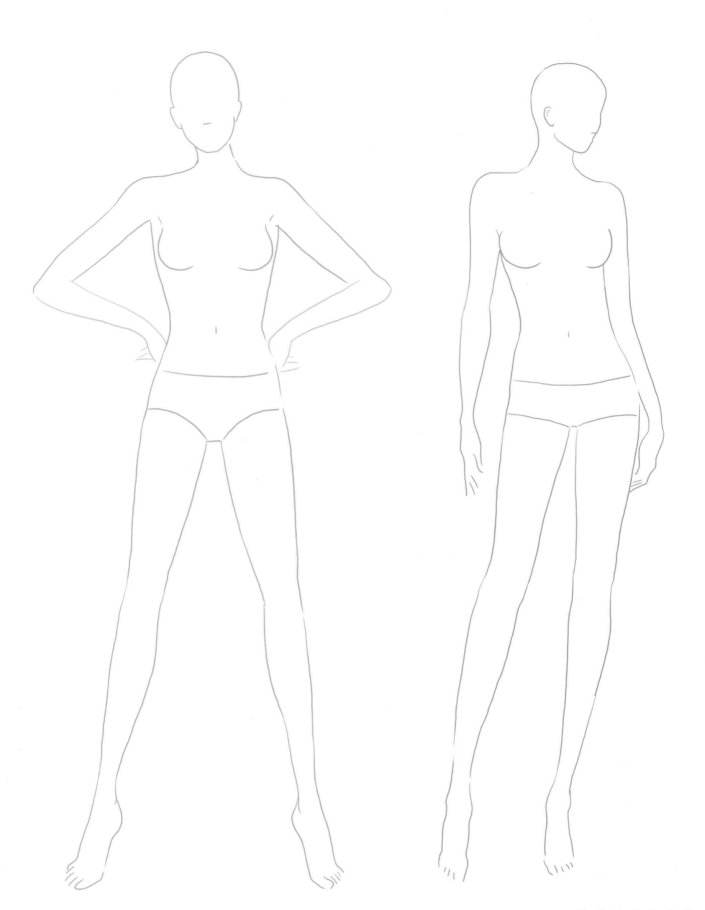

Glamour

The essence of glamour

Old-Hollywood actresses such as Marilyn Monroe, Audrey Hepburn and Elizabeth Taylor epitomize glamour. Glamour is perpetuated today by captivating women who stroll dreamily in front of the cameras at film festivals; this style is still the very essence of femininity.

For all the elegant, spellbinding, society women who grace the galas, catwalks, cocktail parties and other evening events, 'glam' is a much-prized asset.

Be glam: learn to exude all the magic of seduction in a look, a glance, a perfume or a dress!

Glamour look

Long sheath dresses with open backs plunging below the waist. A slim-fitting bolero with satin lining, high-heeled courts with ankle straps and spotted stockings.

Matching earrings and sparkling necklaces and a little diamanté clutch bag, containing nail polish, blusher and lipstick.

The eternal glamour icon

MARILYN!

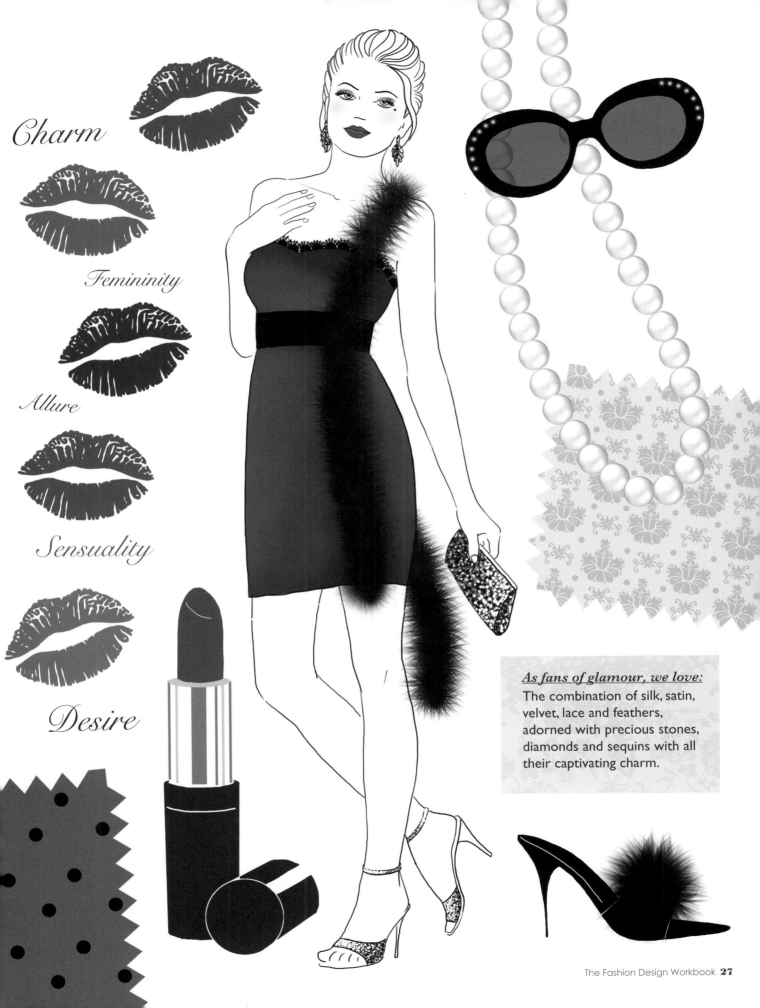

Charm

Femininity

Allure

Sensuality

Desire

As fans of glamour, we love:
The combination of silk, satin, velvet, lace and feathers, adorned with precious stones, diamonds and sequins with all their captivating charm.

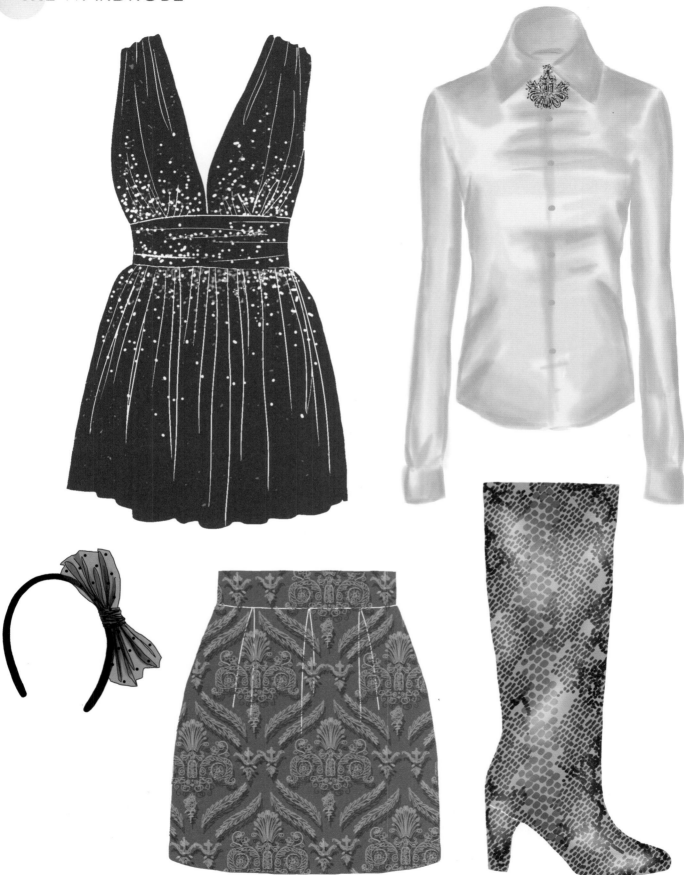

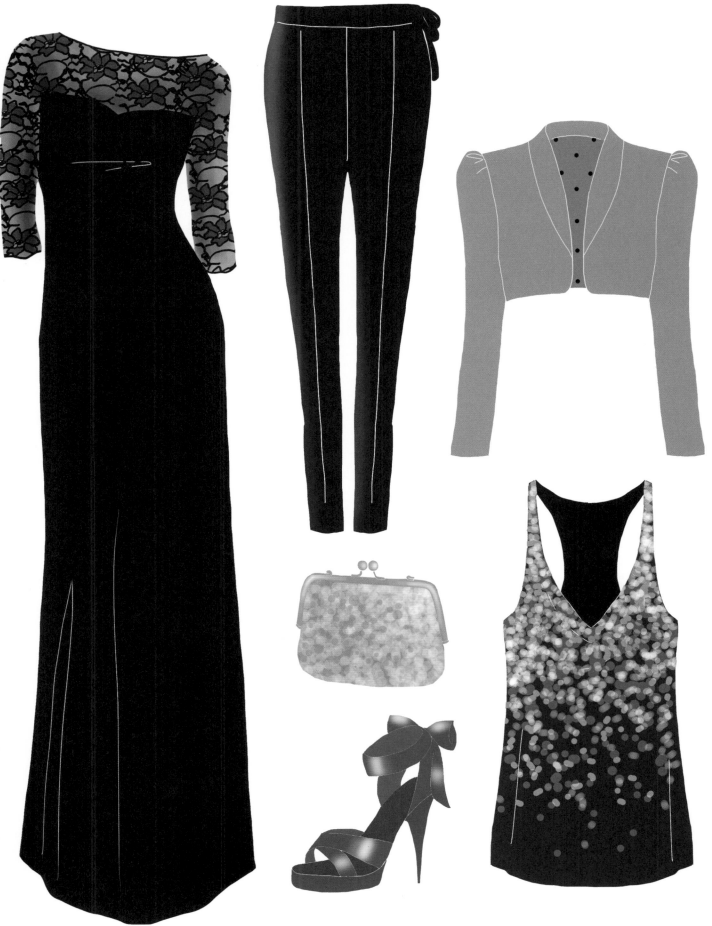

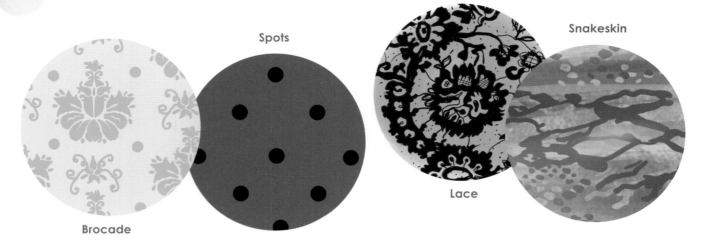

Brocade

Spots

Lace

Snakeskin

1

2

3

4

Diamanté

1. Paint a plain background.

2. Using a paintbrush (or marker pen), dot some little spots of paint that are lighter than the background.

3. Using a paintbrush (or marker pen), dot little spots of colour on top that are even lighter than the colour you used previously.

4. Finish by dotting on some little white spots in the same way.

This technique is used for all diamantés, always finishing with some white.

Satin

1. Apply a plain colour in ink, felt tip or paint.

2. Apply some white pastel crayon here and there to look like reflections and shine. Smudge using your finger.

1

2

Brocade pattern

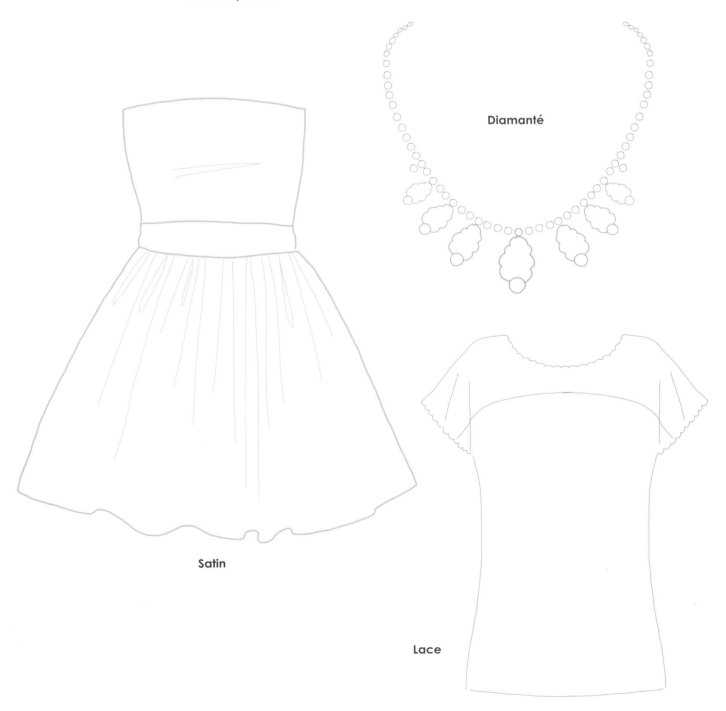

Diamanté

Satin

Lace

GLAMOUR FASHION FIGURES
TO DRESS AND ACCESSORIZE

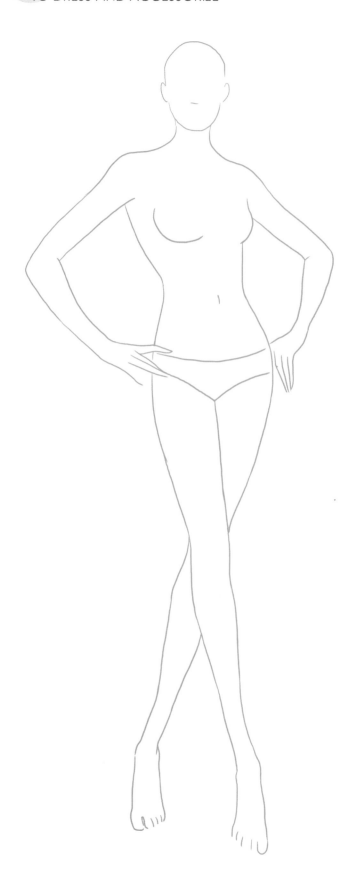
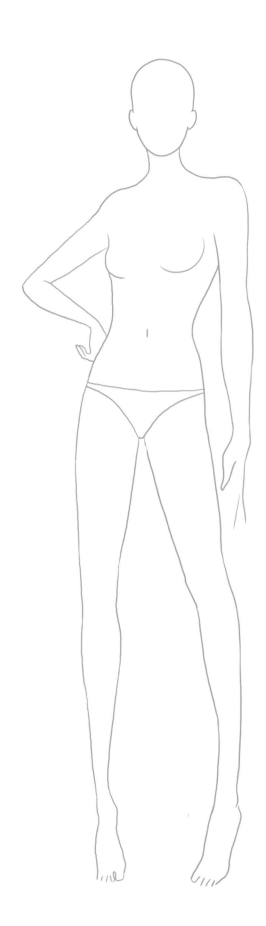

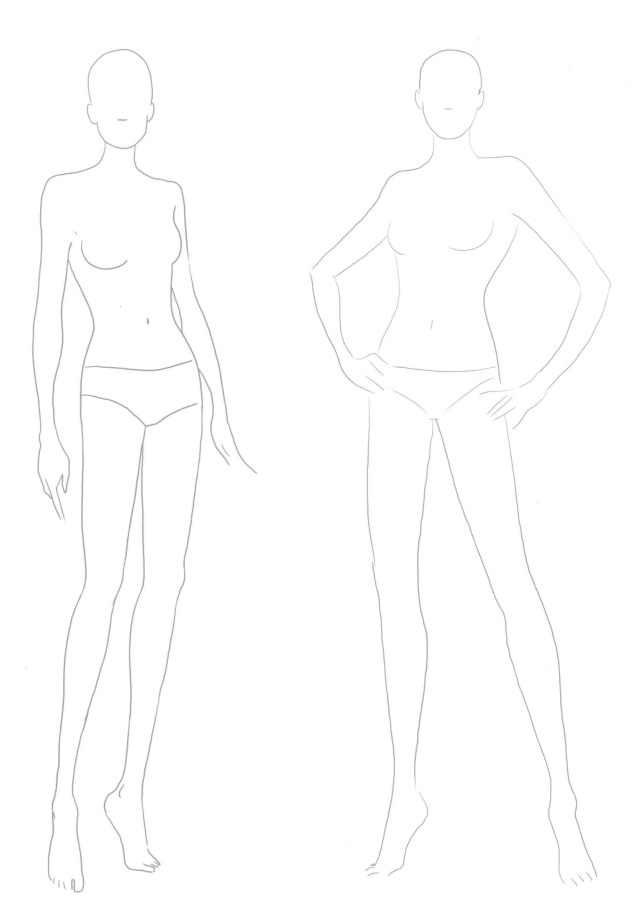

Romantic

Essence of romantic style

It's time to wake up the little girl inside you – to rediscover your childhood, to feel frivolous and beautiful, like a pretty flower, with your head in the clouds.

Romantic style is delicate, fresh, completely natural and without any pretence or razzmatazz. It's all about a melancholic, innocent and hazy allure, but take note, the romantic is a great seductress!

Romantic look

Floaty blouses and long skirts.

Broderie Anglaise dresses or summer playsuits.

Mohair sweaters with open backs, reed baskets and plaited headbands.

Flat gladiator sandals or wedge heels.

Romantic icons

All the heroines in the most beautiful, romantic films!

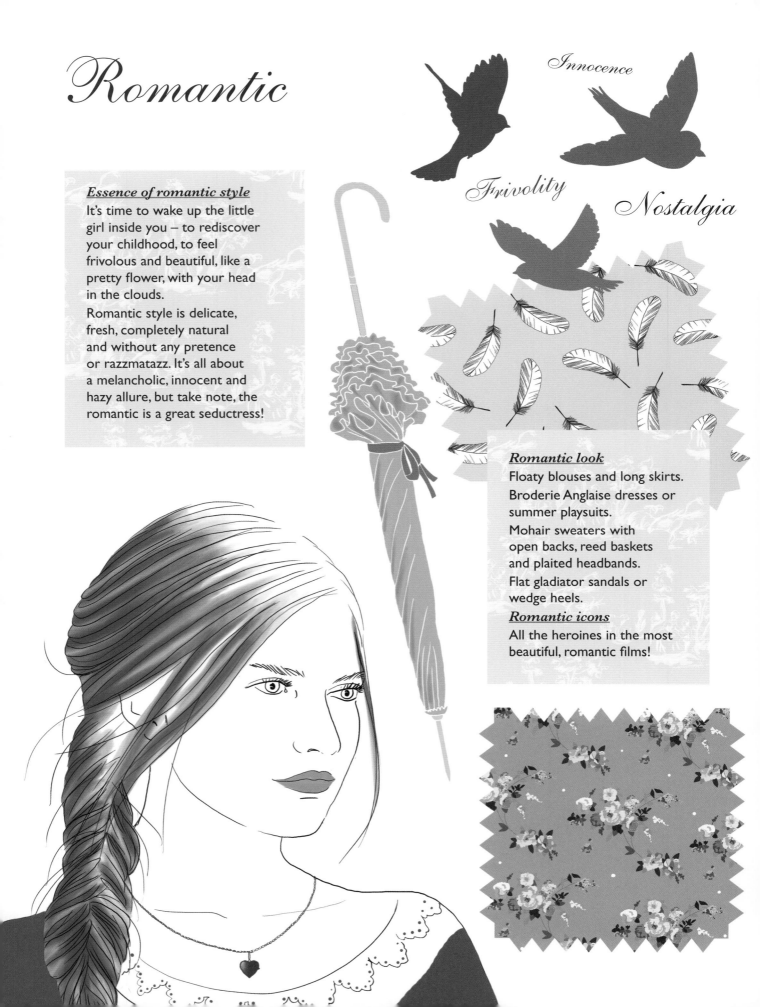

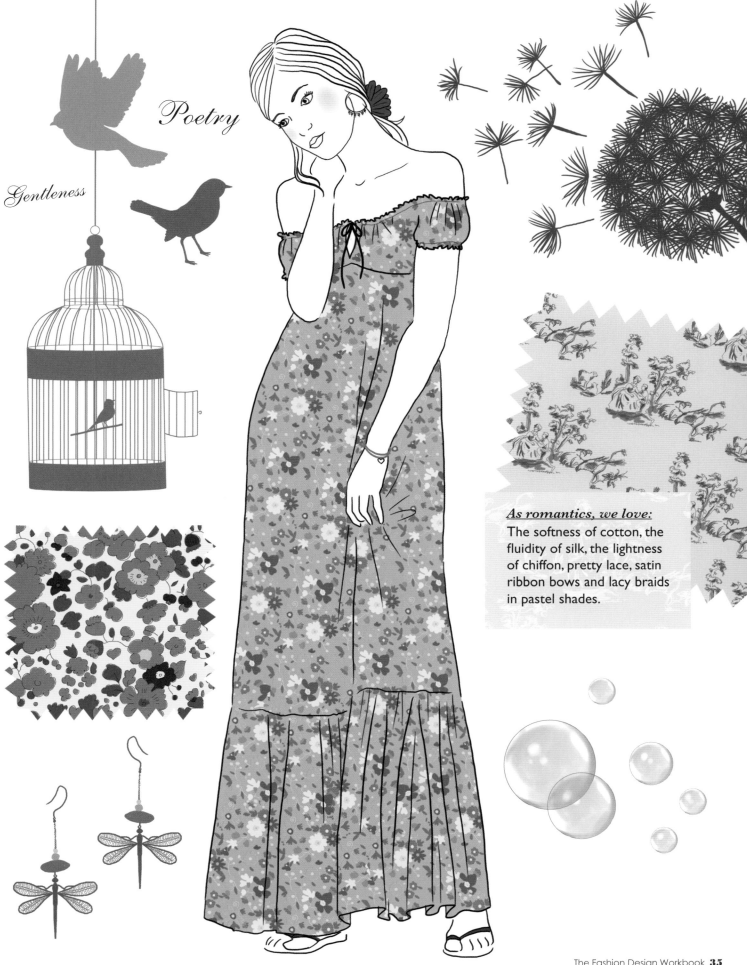

Poetry

Gentleness

As romantics, we love:
The softness of cotton, the fluidity of silk, the lightness of chiffon, pretty lace, satin ribbon bows and lacy braids in pastel shades.

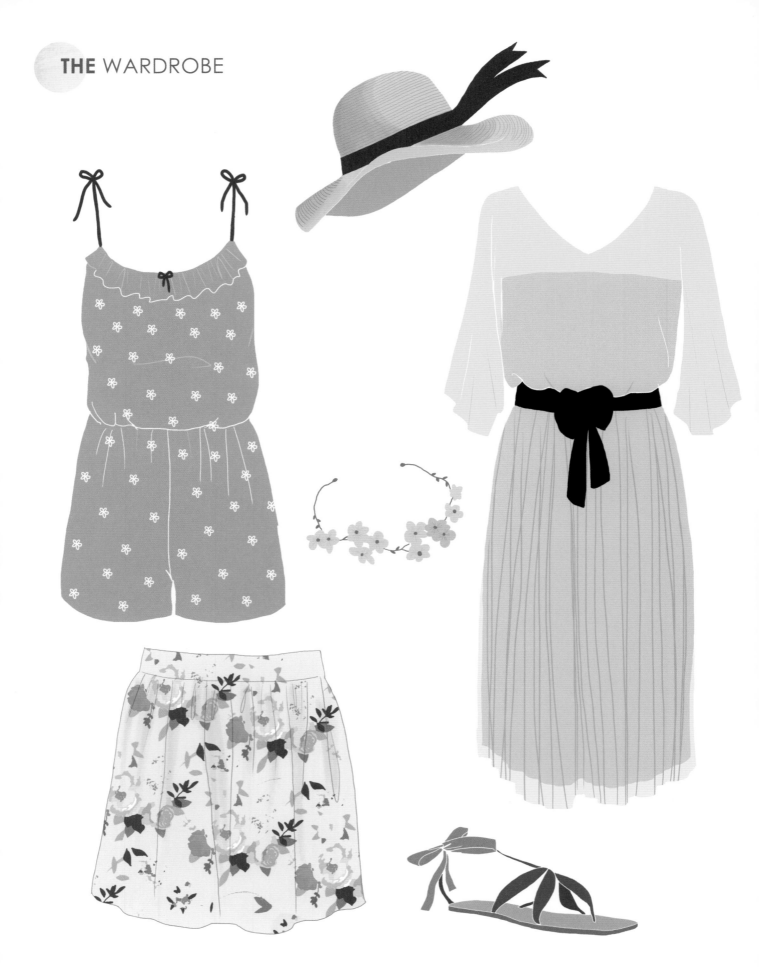

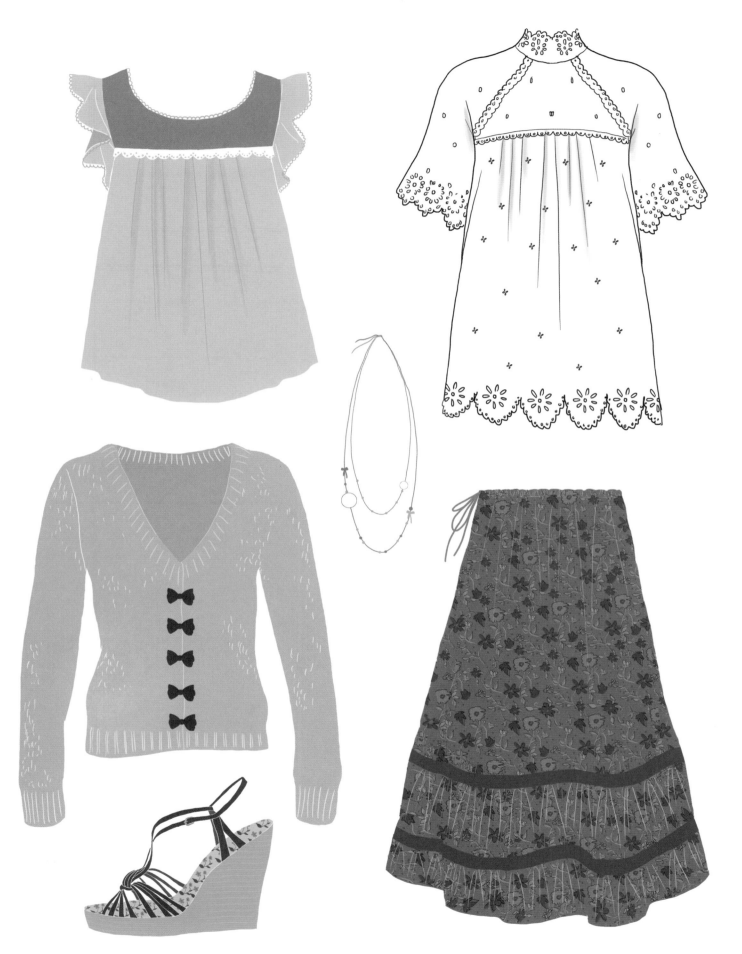

PATTERNS, FABRICS & TECHNIQUES

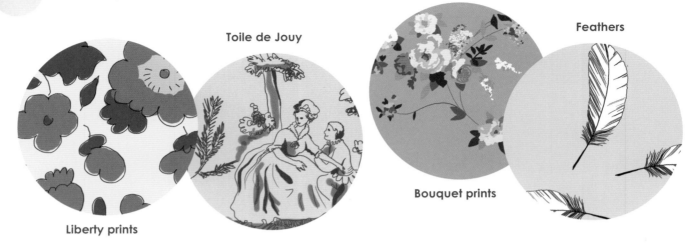

Toile de Jouy

Feathers

Liberty prints

Bouquet prints

Liberty prints

1. Draw your own motifs of fruit and flowers using a pencil.

2. Use tracing paper to repeat the motif in a random pattern.

3. Apply colour to the motifs using paint or ink.

4. Erase the pencil outlines and add a bit of creativity: spots, foliage, stars, etc.

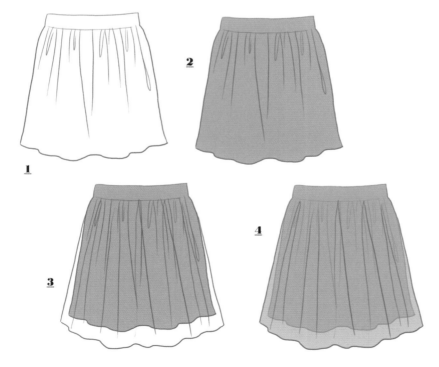

Chiffon

1. Draw a piece of clothing, a romantic skirt for example.

2. Apply some colour using a watercolour crayon, watercolour paint or ink.

3. Draw a chiffon skirt over the original skirt, overlapping the edges.

4. Apply colour to the chiffon skirt using a watercolour crayon, watercolour paint or ink with added water to give the transparent effect of chiffon.

Broderie Anglaise patterns

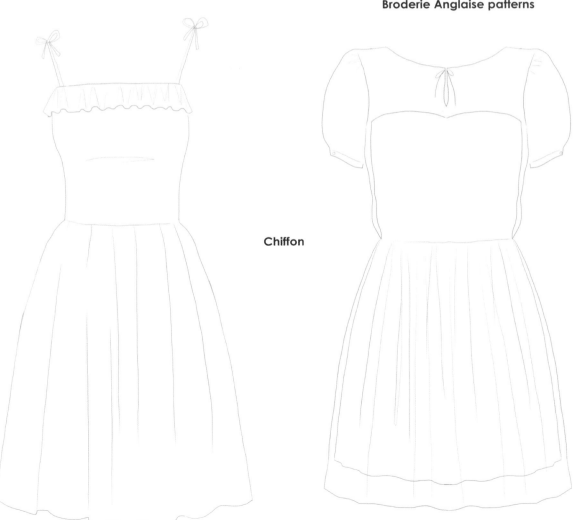

Chiffon

ROMANTIC FASHION FIGURES
TO DRESS AND ACCESSORIZE

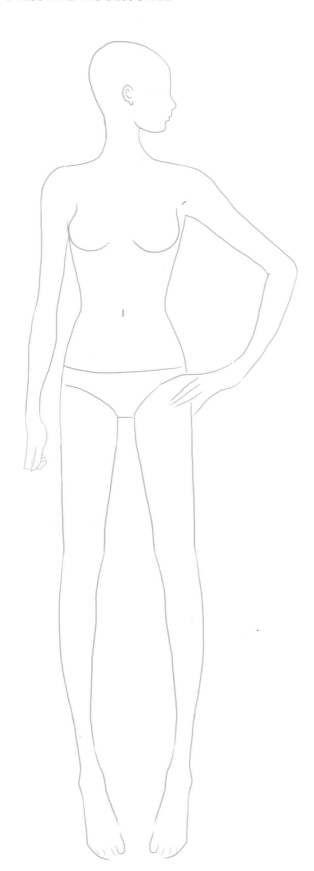

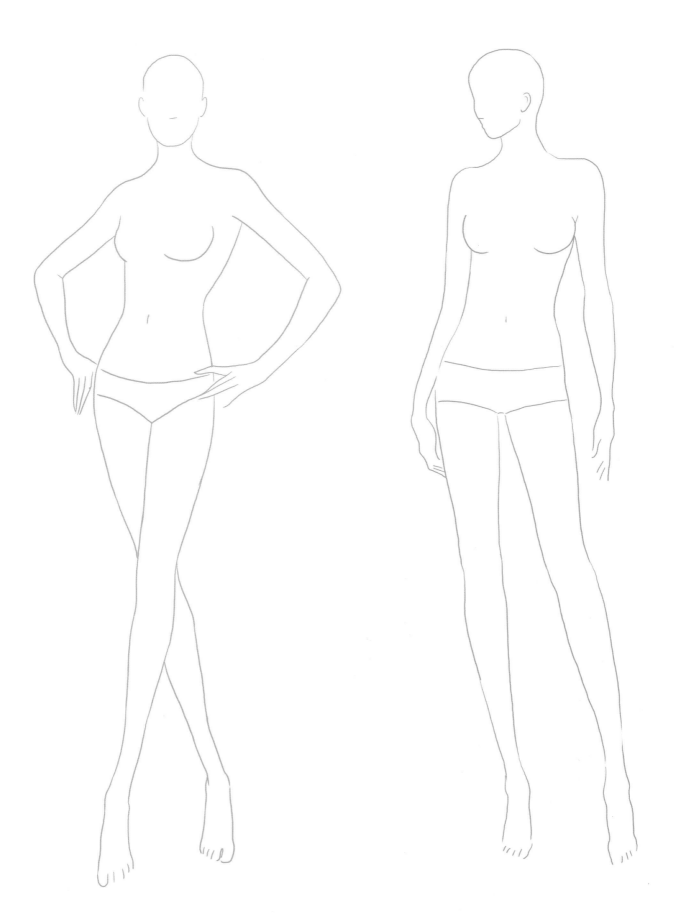

STREETWEAR

Essence of streetwear

Fashion is on the street, the tarmac, along the walls and the pavements. Whether you are a rapper, rollerblader, biker, graffiti artist, break-dancer or just love urban style, the streetwear look is for you: a functional, creative, colourful and energetic style that emphasizes the silhouette and releases artistic expression.

The style comes from cool attitude and claims to be at the cutting edge of fashion and technology; it is all about identity, brand and comfort!

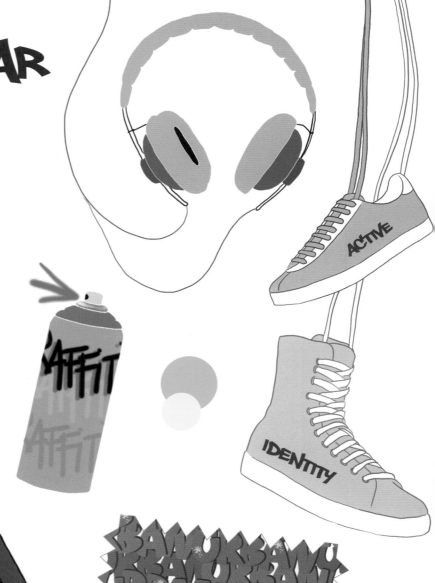

Streetwear look

A flecked grey hoody or flashy tracksuit top with versatile cotton leggings.

T-shirts with brand logos and fleece jogging pants.

Baggy, hard wearing, khaki canvas trousers, sleeveless body warmer and an XXL cap.

The latest trainers and a large, plastic watch.

Streetwear icons

Peggy Oki, Lauryn Hill, Missy Elliott.

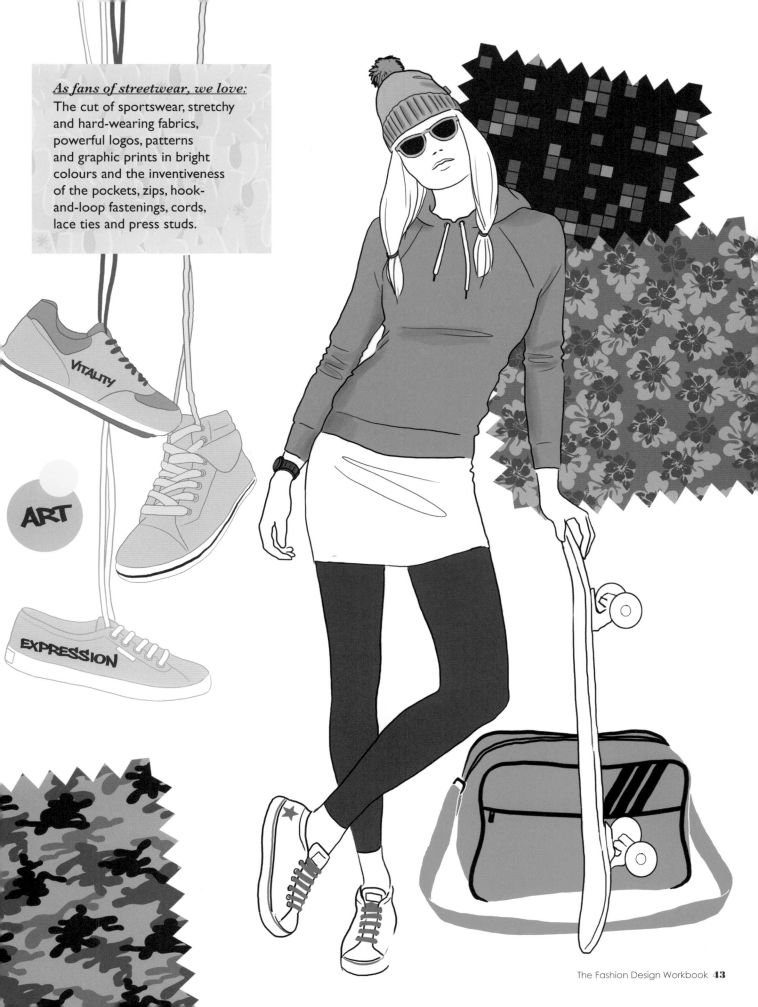

As fans of streetwear, we love:
The cut of sportswear, stretchy and hard-wearing fabrics, powerful logos, patterns and graphic prints in bright colours and the inventiveness of the pockets, zips, hook-and-loop fastenings, cords, lace ties and press studs.

VITALITY

ART

EXPRESSION

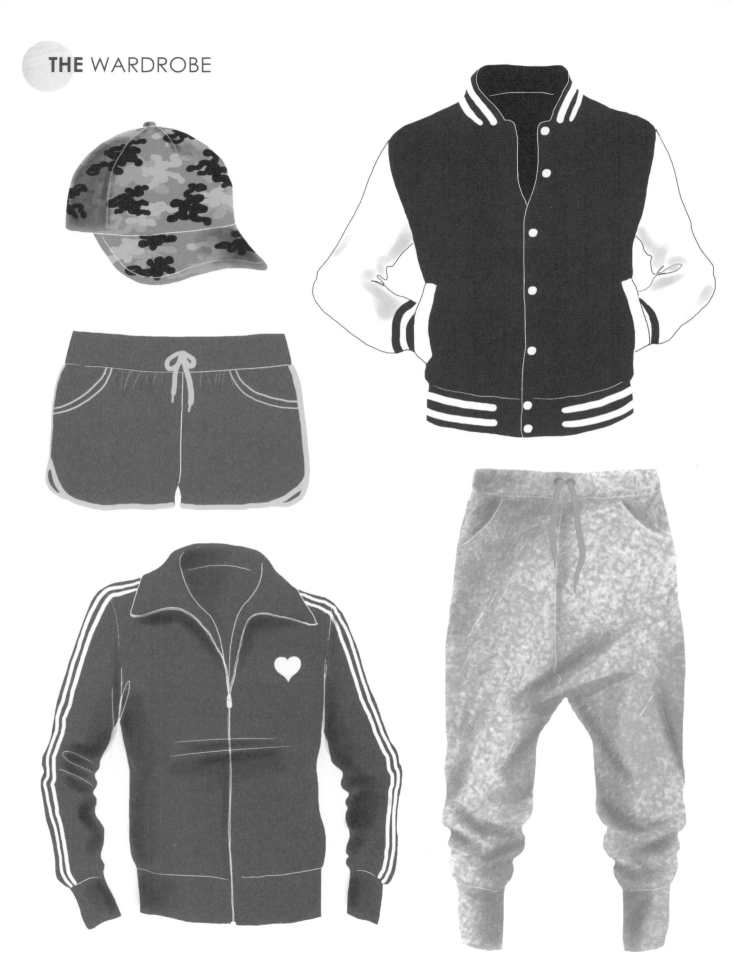

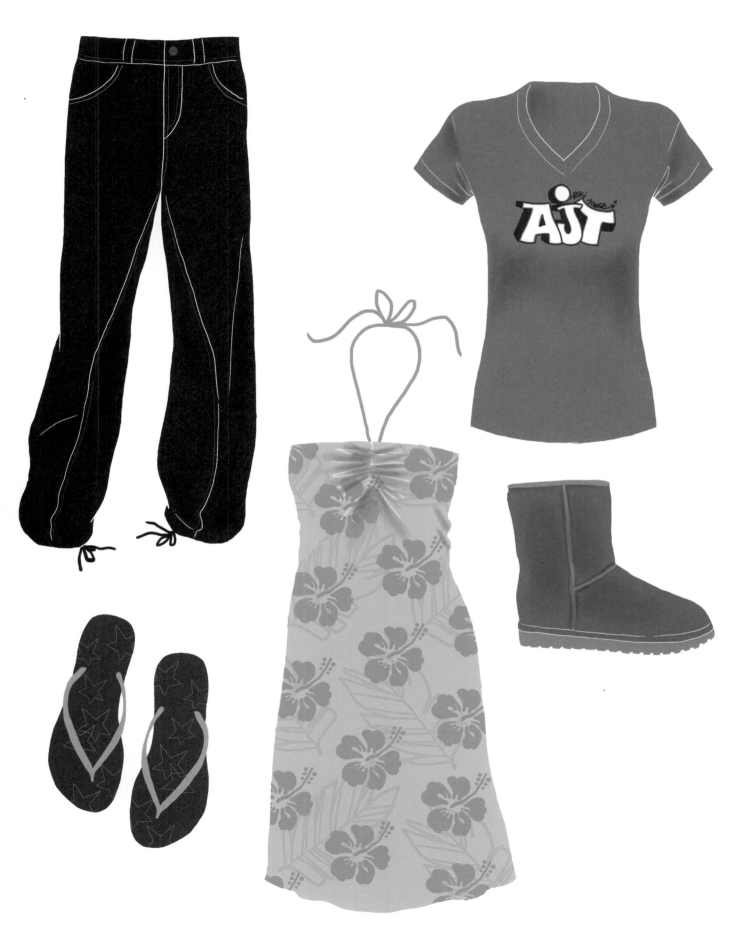

PATTERNS, FABRICS & TECHNIQUES

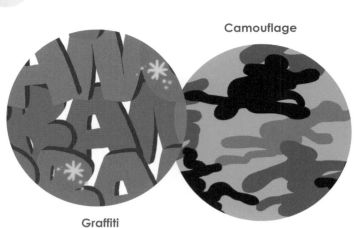

Graffiti

Camouflage

Hawaii

Pixels

Camouflage print

1. Fill in your drawing with some paint, ink or felt tip in a light colour.

2. Using paint, ink or felt tip, make some darker, irregular markings over this background.

3. Then make some more irregular markings in a different colour.

4. Make more markings in a darker colour on top of all of these irregular markings.

1

2

3

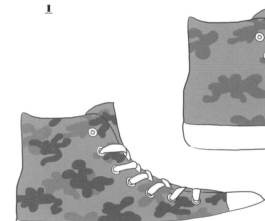

4

Jersey fabric, in flecked grey

1. Apply some paint or ink in a light grey colour.

2. Once it is dry, apply white pastel flecks.

1

2

Grey, flecked sweatshirt

Printed camouflage canvas

Graffiti logo

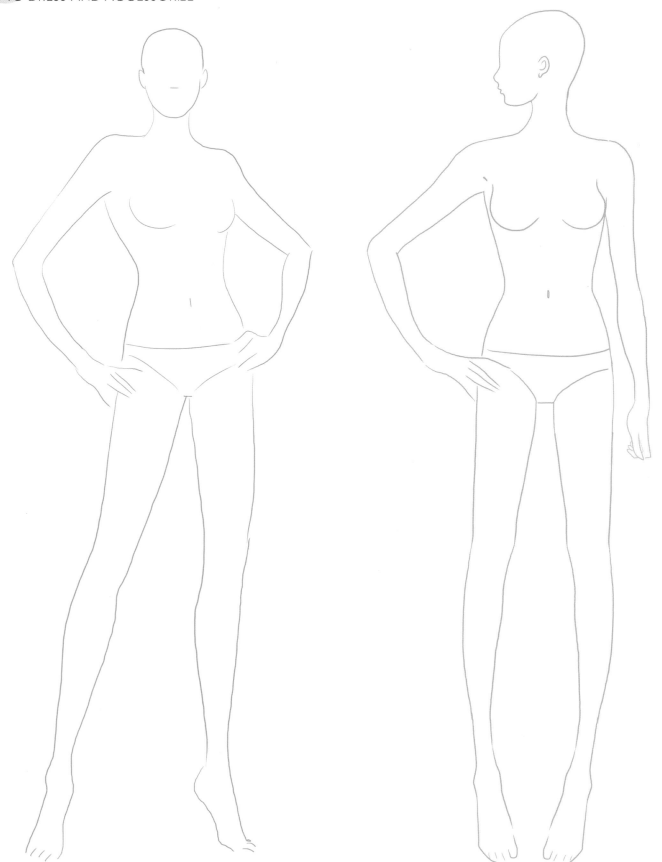

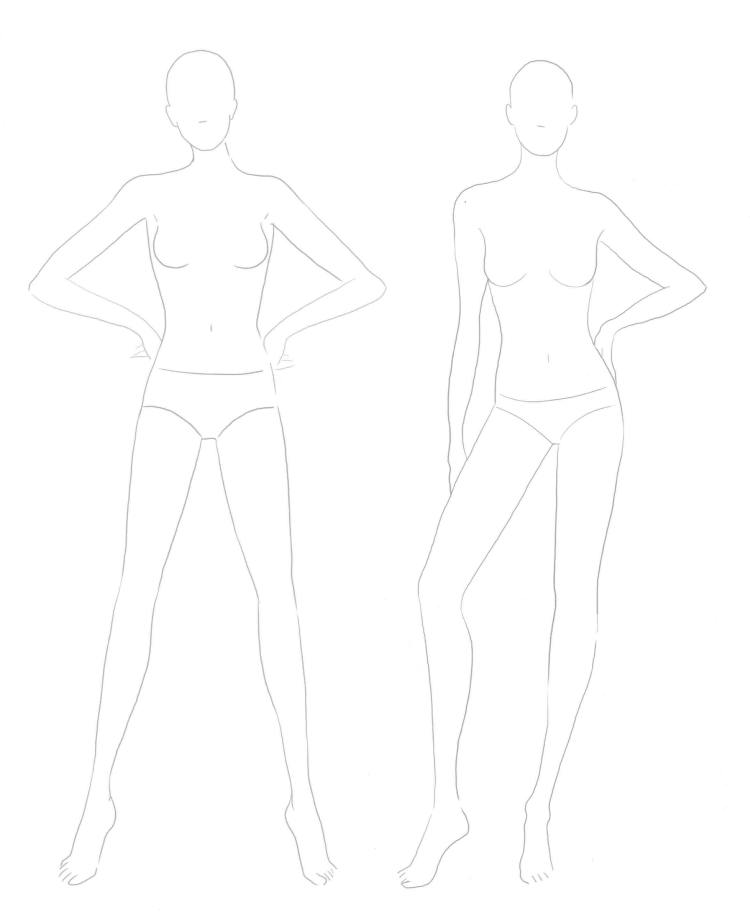

Lolita

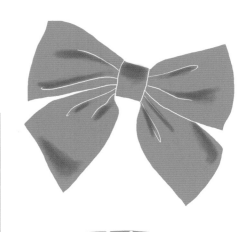

Essence of Lolita

Embodied by the very young heroine of the eponymous novel by Vladimir Nabokov, the Lolita trend continually flirts with fashion and its designers. Maybe it is because there is something innocent, mischievous and delightful in all of us.

Lolita is a more teenage style that is adorable and young, yet deliciously mixed with sexy, spicy perfume.

A fan of the 60s, a little baby doll, a girl in floral fabrics, with her hair in bunches, the fresh face of youth!

Frivolity

Sensuality

Delicacies

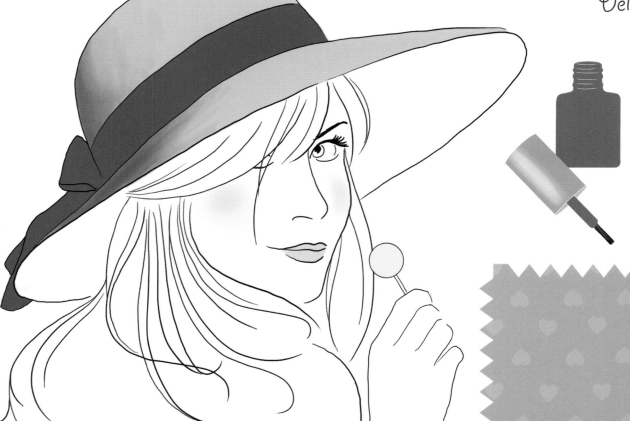

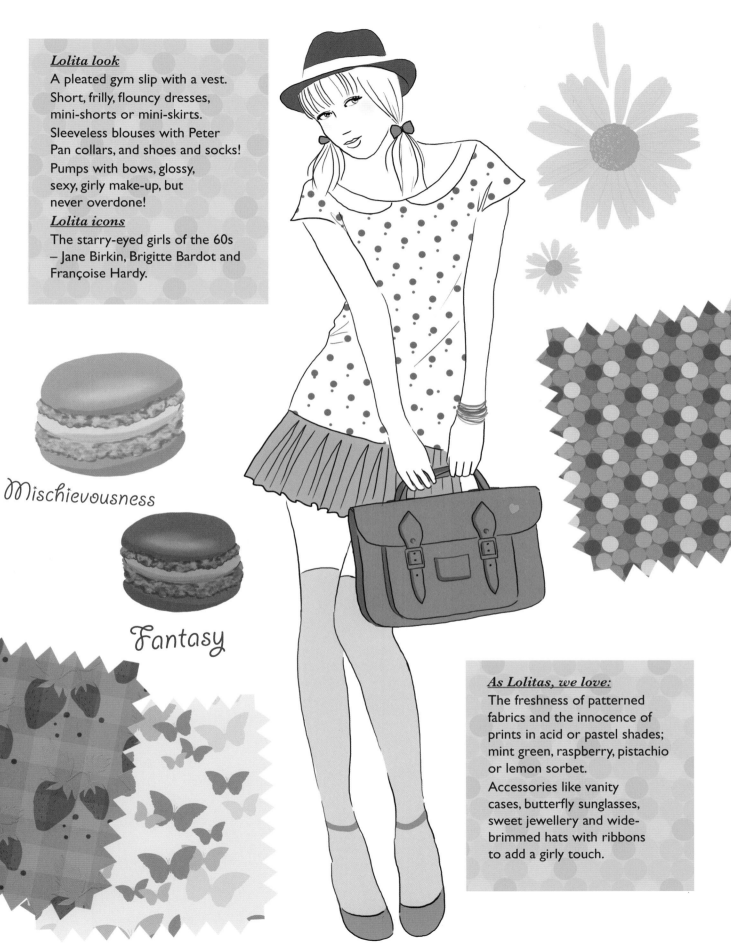

Lolita look

A pleated gym slip with a vest. Short, frilly, flouncy dresses, mini-shorts or mini-skirts. Sleeveless blouses with Peter Pan collars, and shoes and socks! Pumps with bows, glossy, sexy, girly make-up, but never overdone!

Lolita icons

The starry-eyed girls of the 60s – Jane Birkin, Brigitte Bardot and Françoise Hardy.

Mischievousness

Fantasy

As Lolitas, we love:

The freshness of patterned fabrics and the innocence of prints in acid or pastel shades; mint green, raspberry, pistachio or lemon sorbet.

Accessories like vanity cases, butterfly sunglasses, sweet jewellery and wide-brimmed hats with ribbons to add a girly touch.

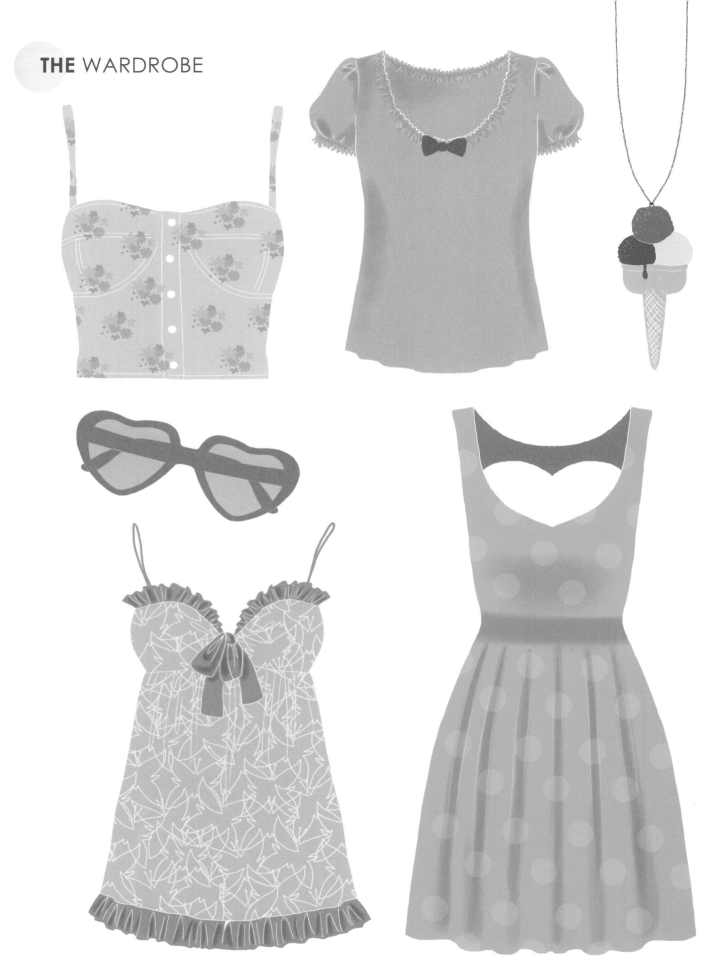

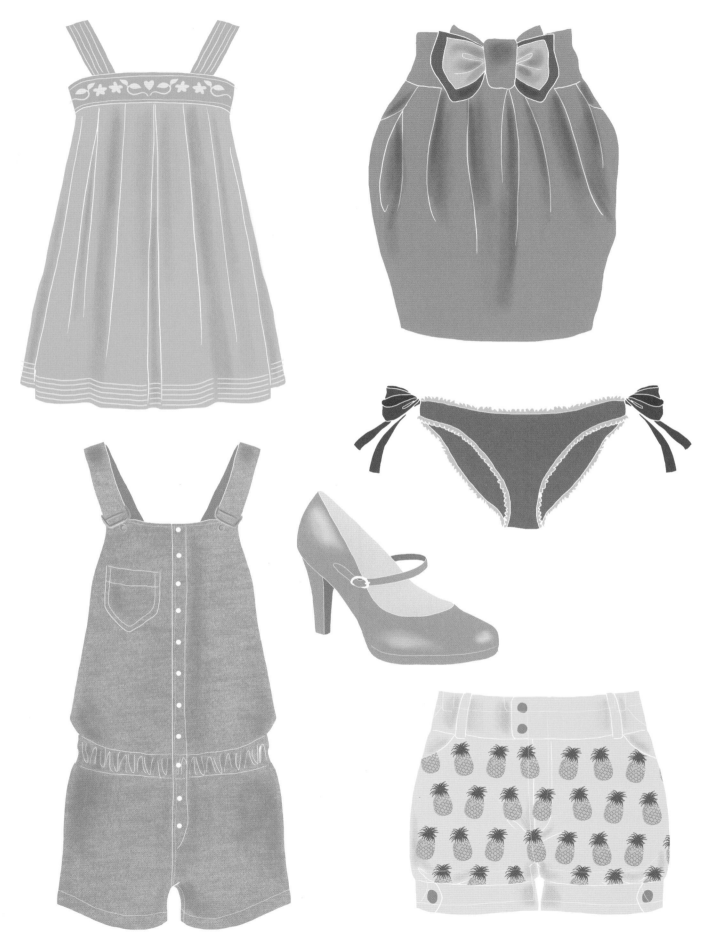

PATTERNS, FABRICS & TECHNIQUES

Hearts

Sweets

Butterflies

Strawberries

Frilly flounce

1. Draw two parallel, horizontal lines with a pencil.

2. Draw a row of pyramids between the lines.

3. Using a felt tip or ballpoint pen, curve the sides of the pyramids then draw a wavy line underneath the flounce following the ends of the pyramids.

4. Draw a straight line at the top and fill in the sides, then erase the pencil lines.

5. After applying the colour, use a white pencil to smudge the outside edges of the folds in the flounce to get a 3D effect.

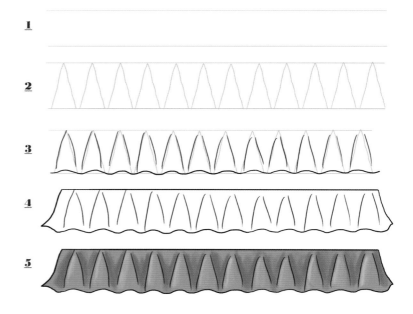

1

2

3

4

5

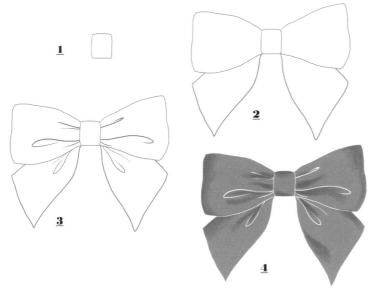

1

2

3

4

Bow

1. Using a pencil, draw the centre of the bow in the shape of a square or rectangle.

2. Draw the two top and bottom parts of the bow either side of the centre.

3. Draw the folds of the bow to create the fabric effect.

4. Apply the colour with paint, felt tip, ink or coloured pencil, then erase the pencil lines. Apply a darker colour inside the folds and on the sides to create the 3D effect.

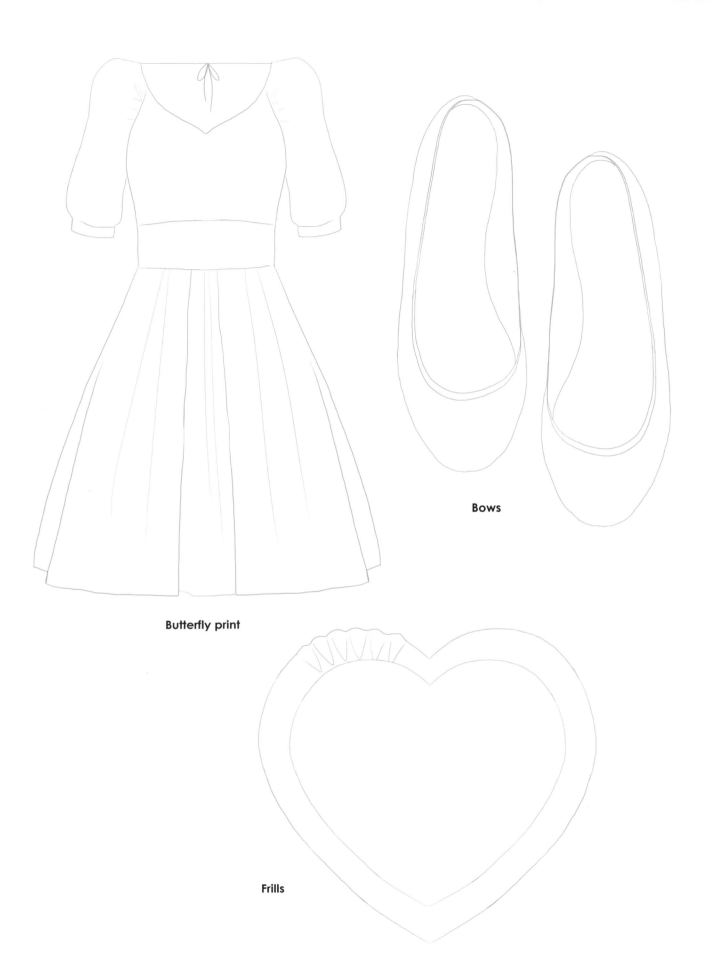

Butterfly print

Bows

Frills

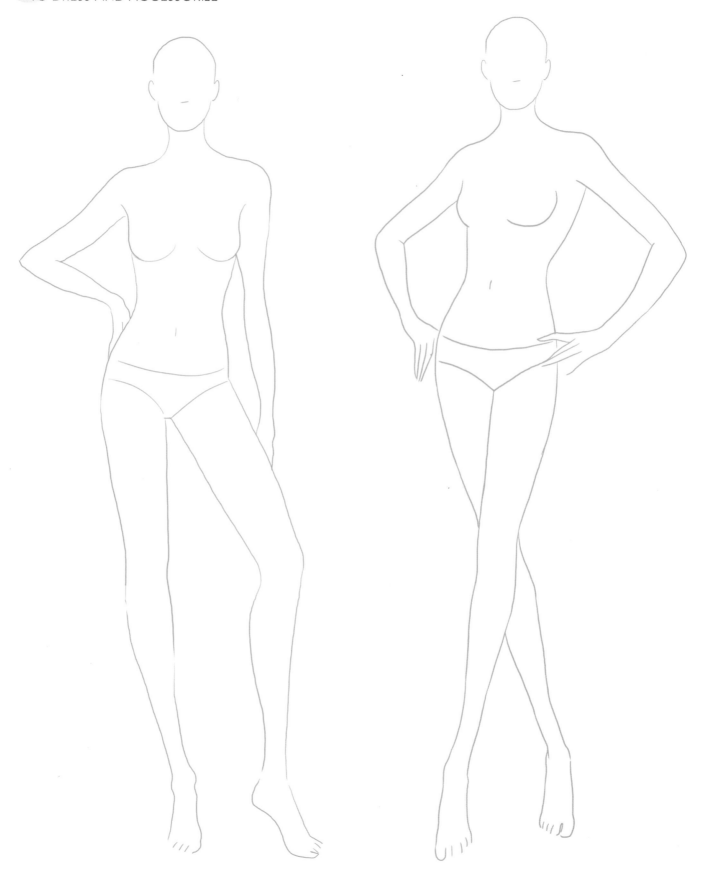

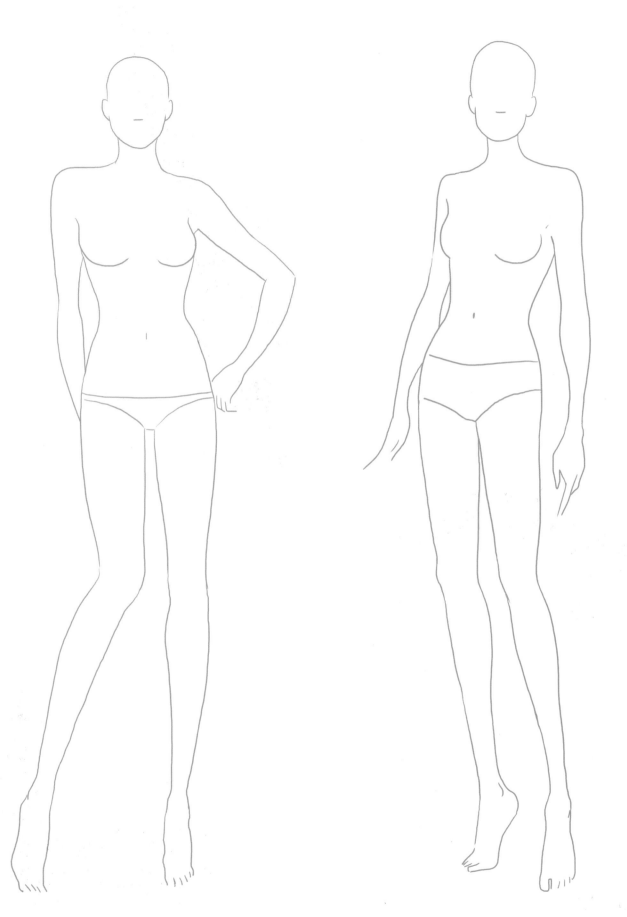

Chic

Essence of chic
You don't need to be the daughter of an aristocrat to be chic. Chic is being immaculately dressed, yet always in fashion, mindful of traditions without ever looking dated, well behaved yet mischievously charming!

Elegant, sophisticated and impeccable – choose the right basics for your wardrobe and above all, avoid eccentricity and poor taste to carry off this style.

Luxury

Sophisticated

Chic look
Jodhpurs buttoned at the ankles, with a fitted blouse that is perfectly ironed!

Duffle coats and roll-neck sweaters with a Hermès scarf, tied according to the season and a string of pearls.

A pair of moccasins, a bag and a luxury-brand watch.

Chic icons
Characters from popular US series such as Charlotte York, Blair Waldorf or Bree Van de Kamp.

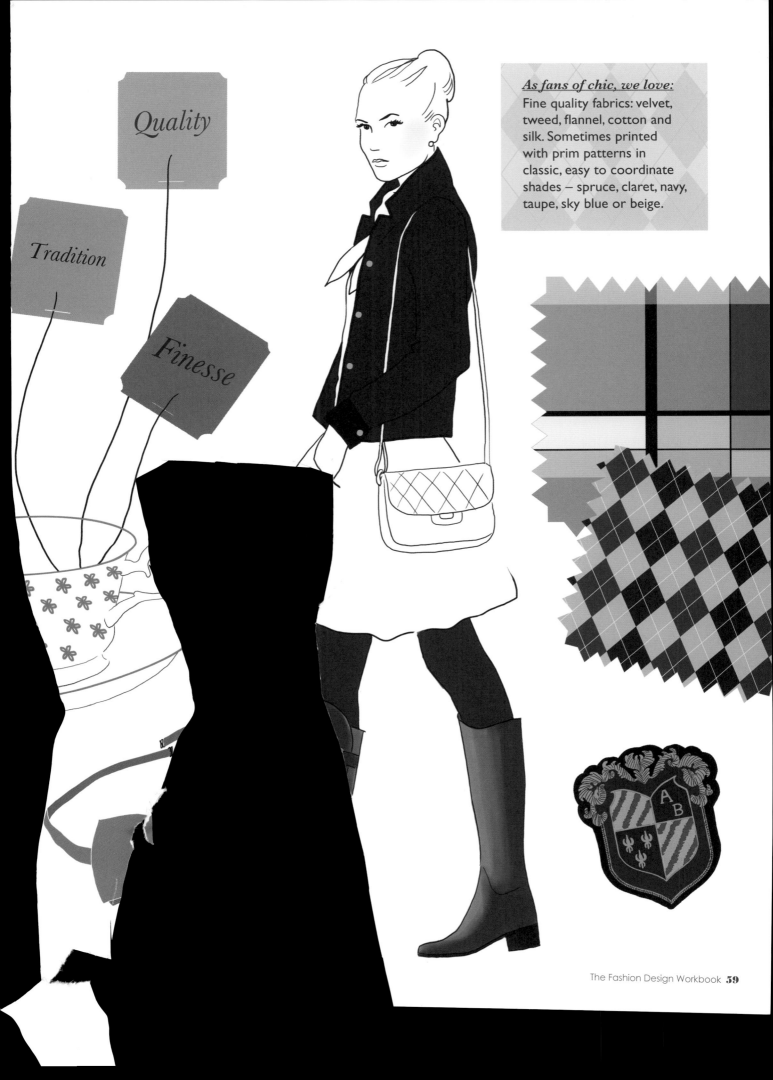

Quality

Tradition

Finesse

__As fans of chic, we love:__
Fine quality fabrics: velvet, tweed, flannel, cotton and silk. Sometimes printed with prim patterns in classic, easy to coordinate shades – spruce, claret, navy, taupe, sky blue or beige.

The Fashion Design Workbook **59**

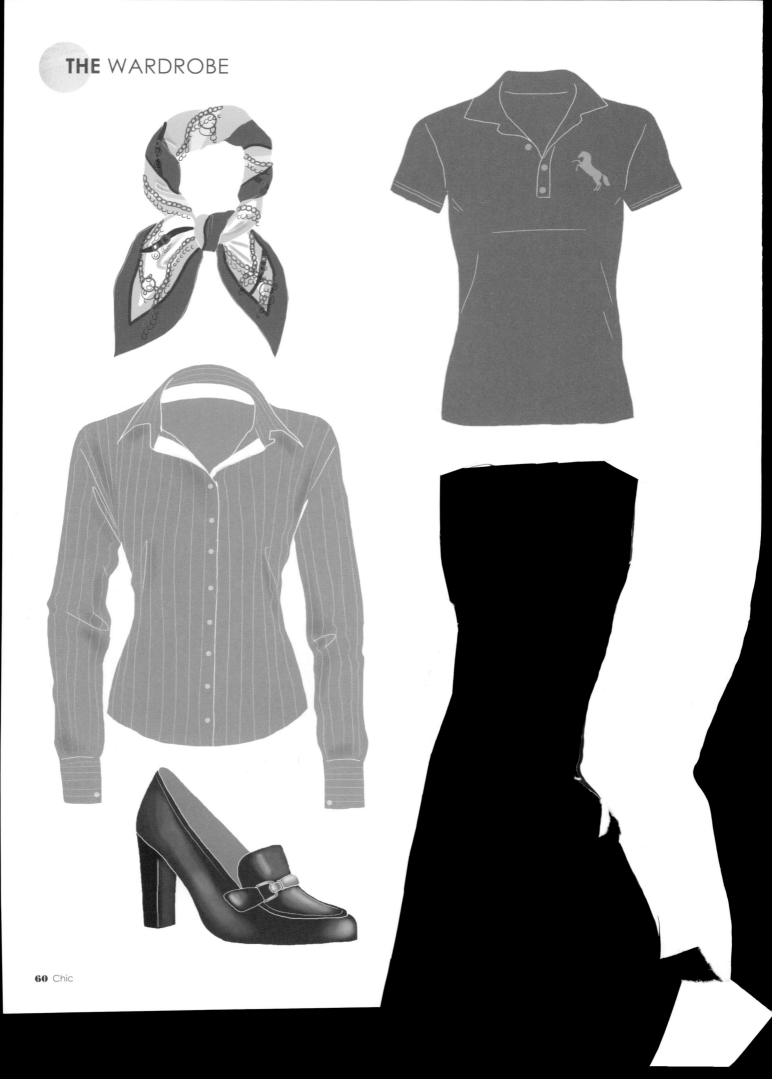

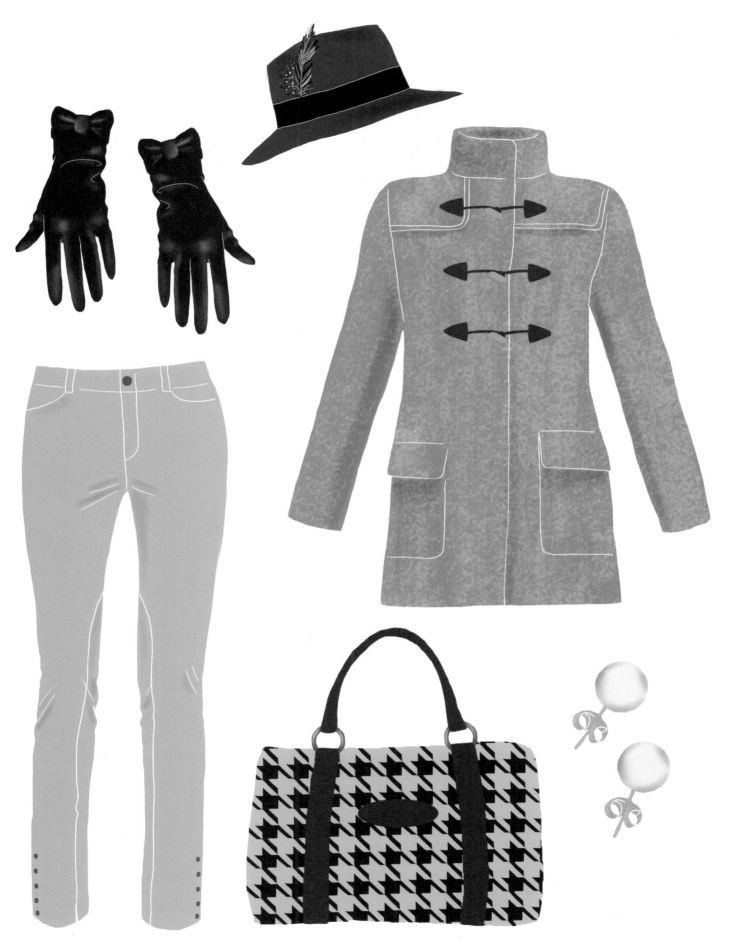

PATTERNS, FABRICS & TECHNIQUES

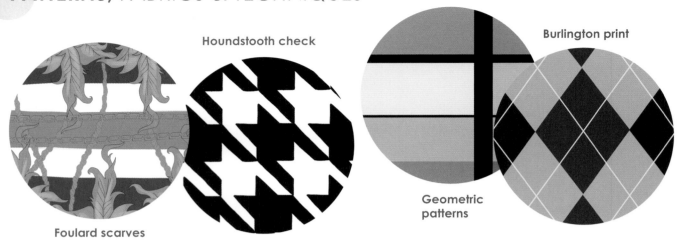

Foulard scarves

Houndstooth check

Geometric patterns

Burlington print

String of pearls

1. Draw the outline of the pearl with a pencil.

2. Fill in the design with paint, ink or coloured pencil choosing a very pale shade of grey, almost white.

3. Emphasize the outline of the pearl with a pencil, then smudge using your finger.

4. Apply a light layer of watercolour pencil or paint in white on to the pearl. Then smudge using your finger to give the pearl volume and a rounded appearance.

5. Erase the outline.

6. Thread the pearls onto your necklace!

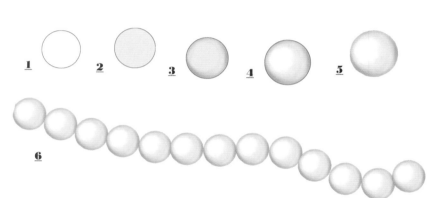

Burlington print pattern

1. Using a pencil, draw a grid, made up of diamonds, then choose three colours to cover these diamonds in a symmetrical pattern.

2. Fill in the diamonds with paint or felt tip according to the colour scheme.

3. Apply diagonal lines in white pencil (or fine marker) crossing the diamonds in their centres.

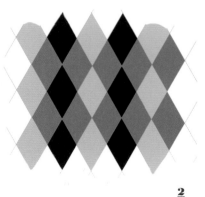

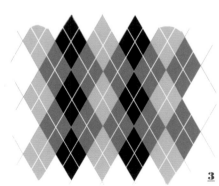

3 chic ways to tie a scarf

City slicker

60s

At the beach

Burlington print

Houndstooth check or tweed

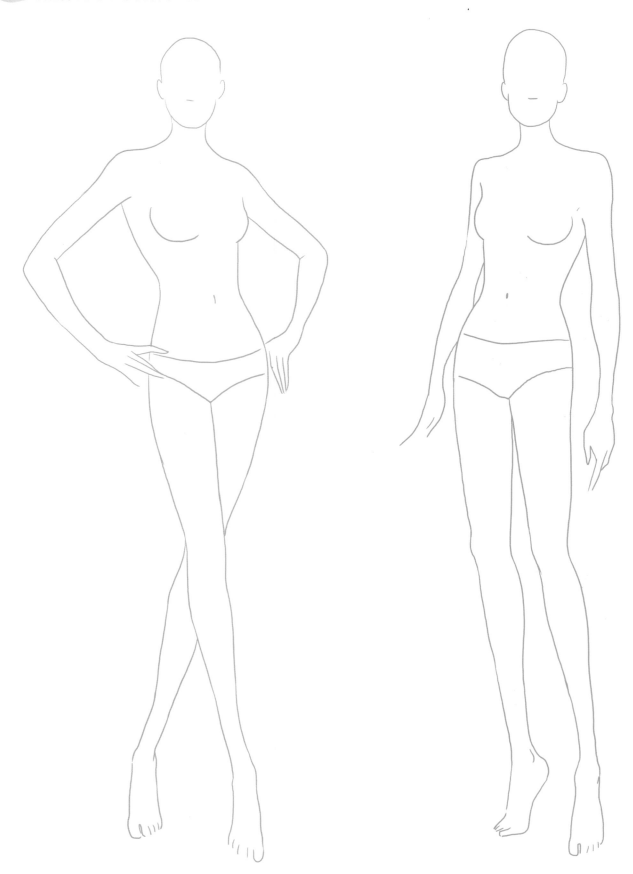

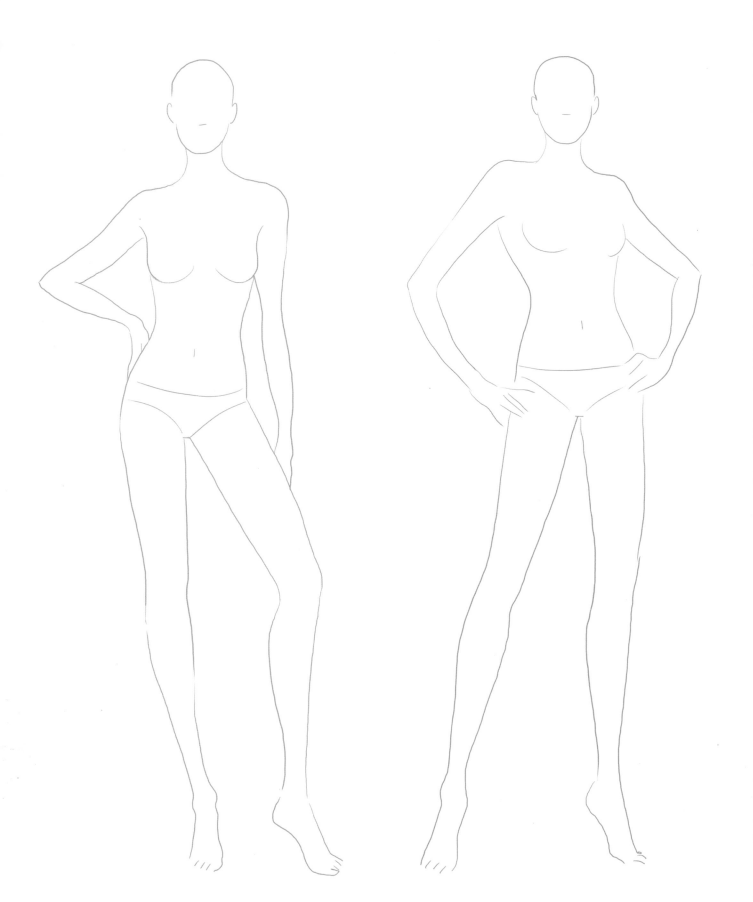

Casual

Essence of casual
Even though this word also means 'relaxed', casual fashion is far from boring!

It is a real phenomenon and a real style, which is nowadays the most well known among designers and journalists, in other words, those who make fashion.

The essence of casual is an exquisite taste for neutrals, a timeless alliance of elegance and convenience…and the result?

A classic yet relaxed look, relaxed with class!

Casual look
Classic, straight-legged jeans with a plain V-neck, roll-neck, boat-neck or round-neck sweater and a blazer or trench coat.

Printed summer dresses.

A pair of flat boots and organizer bag.

A fine chain with a discreet pendant.

Casual icons
Us, you, them…everyone!

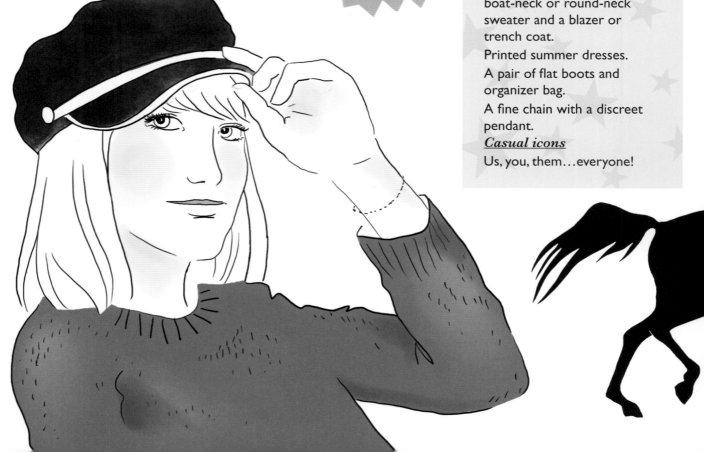

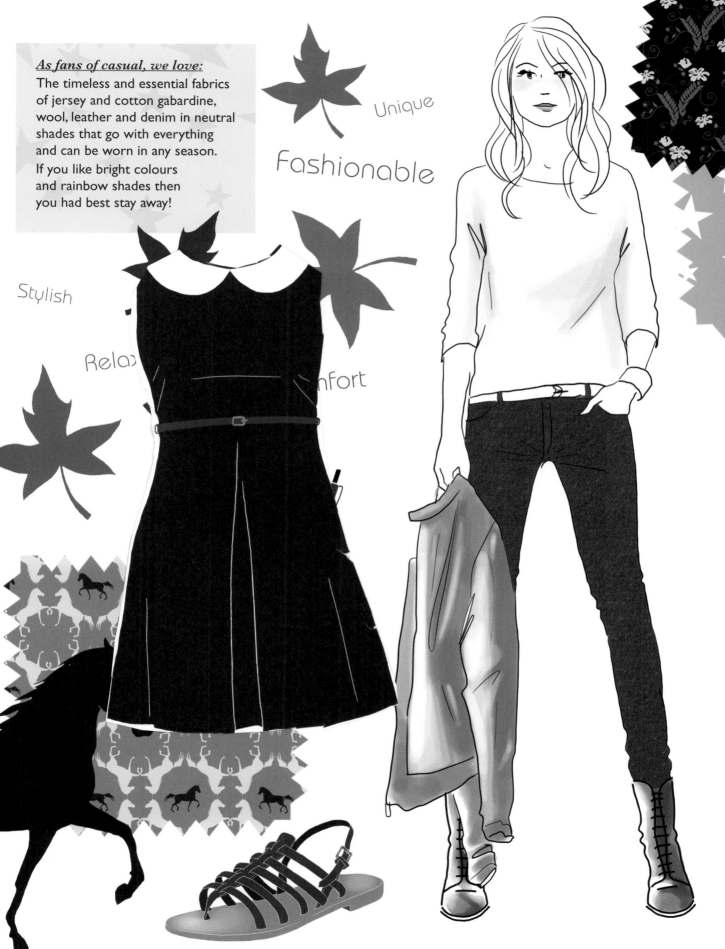

As fans of casual, we love:

The timeless and essential fabrics of jersey and cotton gabardine, wool, leather and denim in neutral shades that go with everything and can be worn in any season.

If you like bright colours and rainbow shades then you had best stay away!

Unique

Fashionable

Stylish

Relax

Comfort

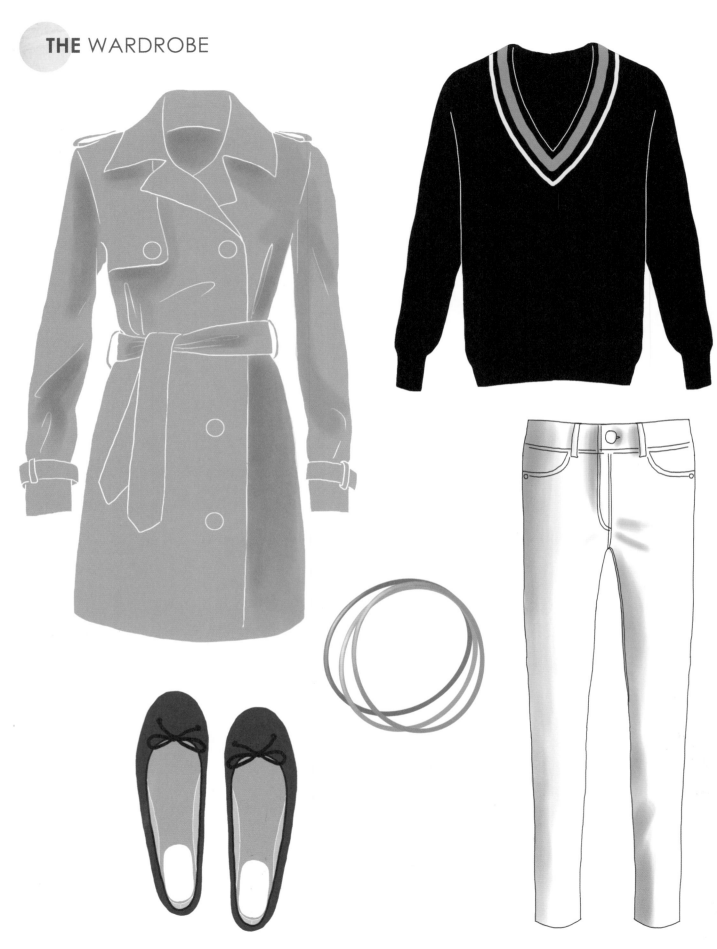

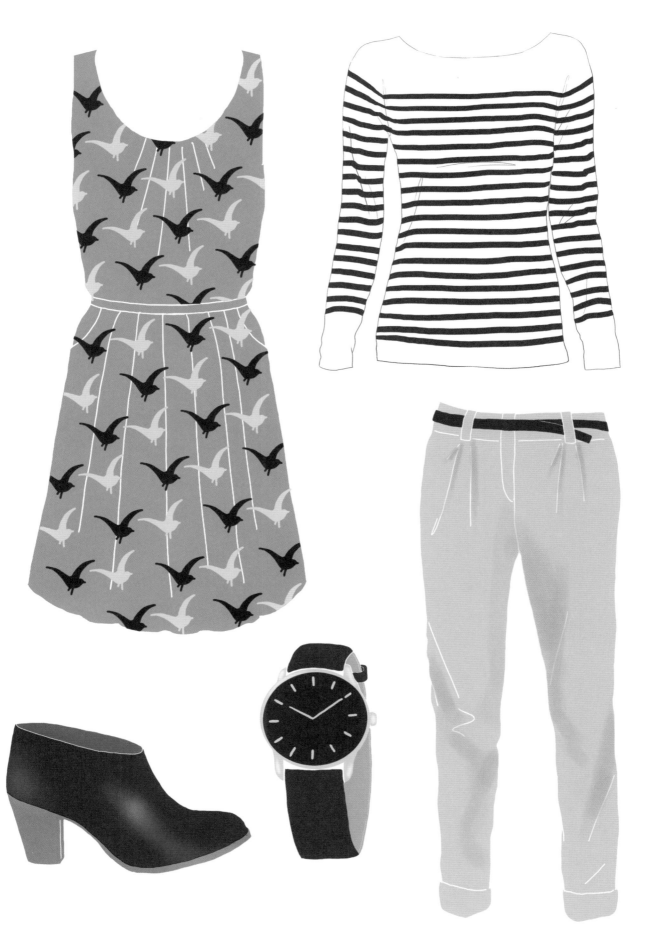

PATTERNS, FABRICS & TECHNIQUES

Nautical stripes

Equestrian

Stars

Foliage

Repeat pattern

1. Draw the outline of the shape with a pencil.

2. Trace the motif onto the clothing at regular intervals.

3. Erase the parts of the motifs that overlap the clothing.

4. Fill in the motifs with felt tip, paint or coloured pencils.

5. Erase the outlines of the motifs.

<u>**1**</u>

<u>**2**</u>

<u>**3**</u>

<u>**4**</u>

<u>**5**</u>

<u>**1**</u>

<u>**2**</u>

<u>**3**</u>

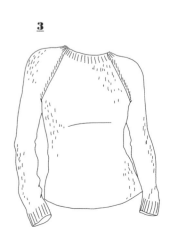

Classic sweater

1. Draw the outlines of the sweater.

2. Mark the ribbed edges on the collar, cuffs and armholes with close lines.

3. Make it look like fabric by hatching the sweater in certain areas to give the effect of wool.

Animal motifs to trace

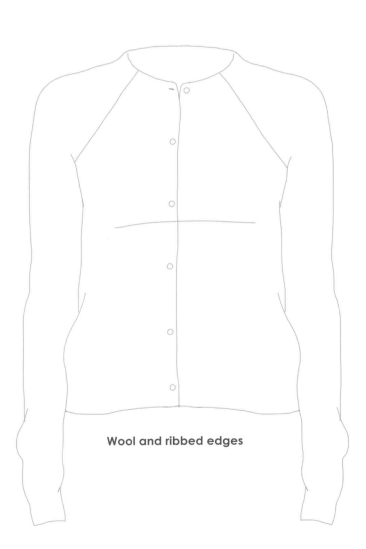

Wool and ribbed edges

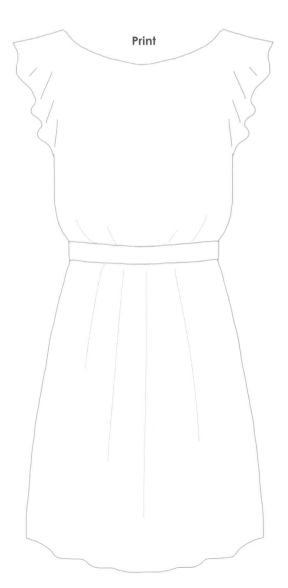

Print

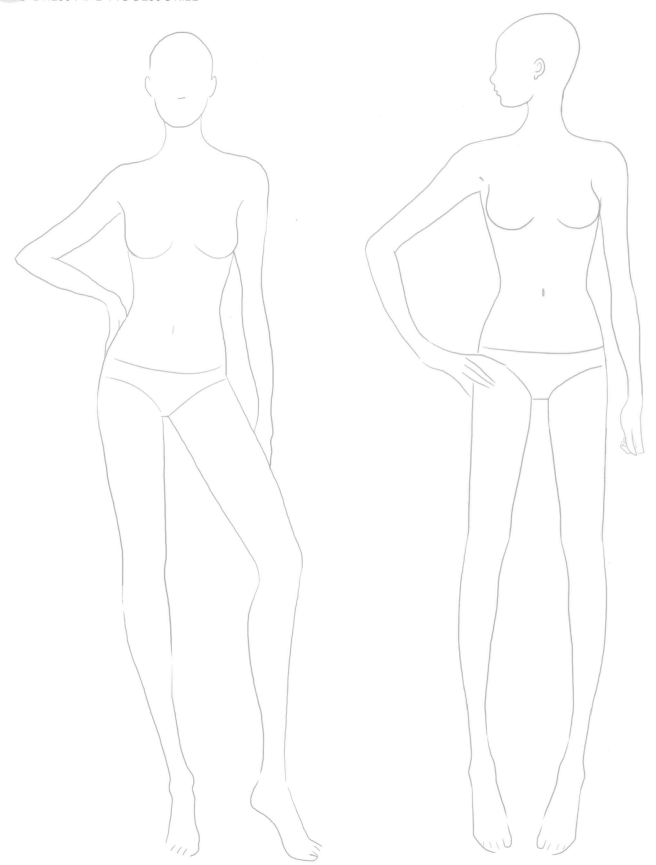

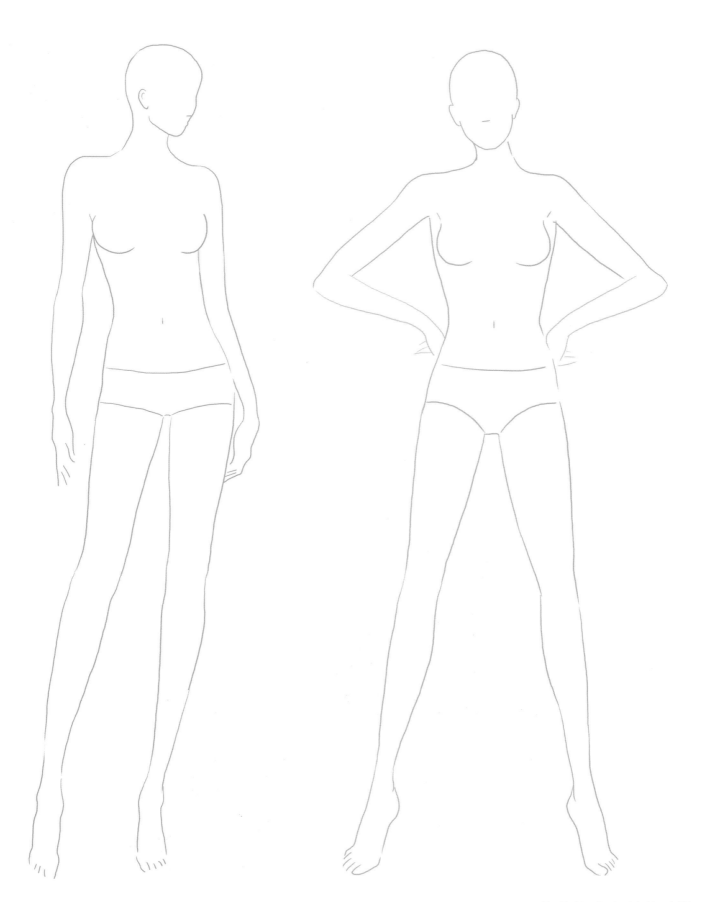

Grunge

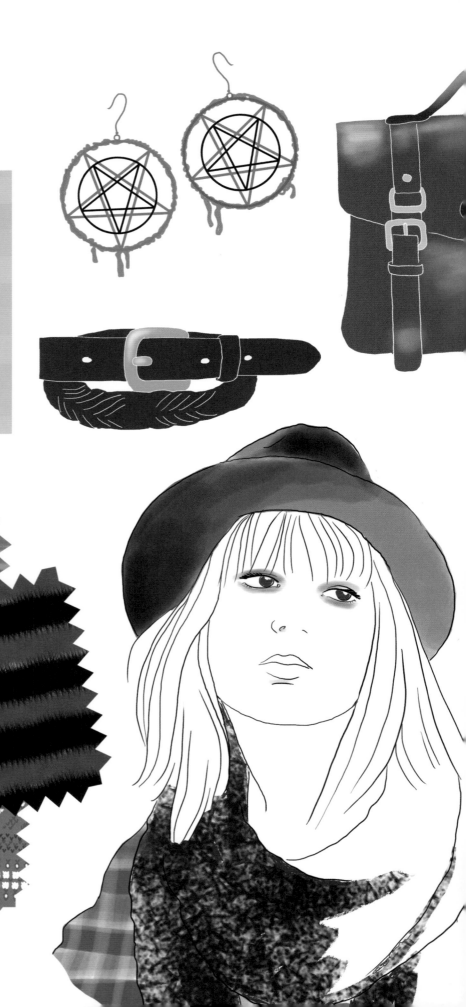

Essence of grunge

Appearing in the 80s in the shape of the sensitive yet rebellious Kurt Cobain and his band Nirvana, grunge embodies indifference and anti-establishment, the reign of scruffy youths, with dishevelled hair and worn out clothes: a messy look.

Nowadays the grunge attitude lives on as the euphemism for a neglected look, but certainly not neglected fashion!

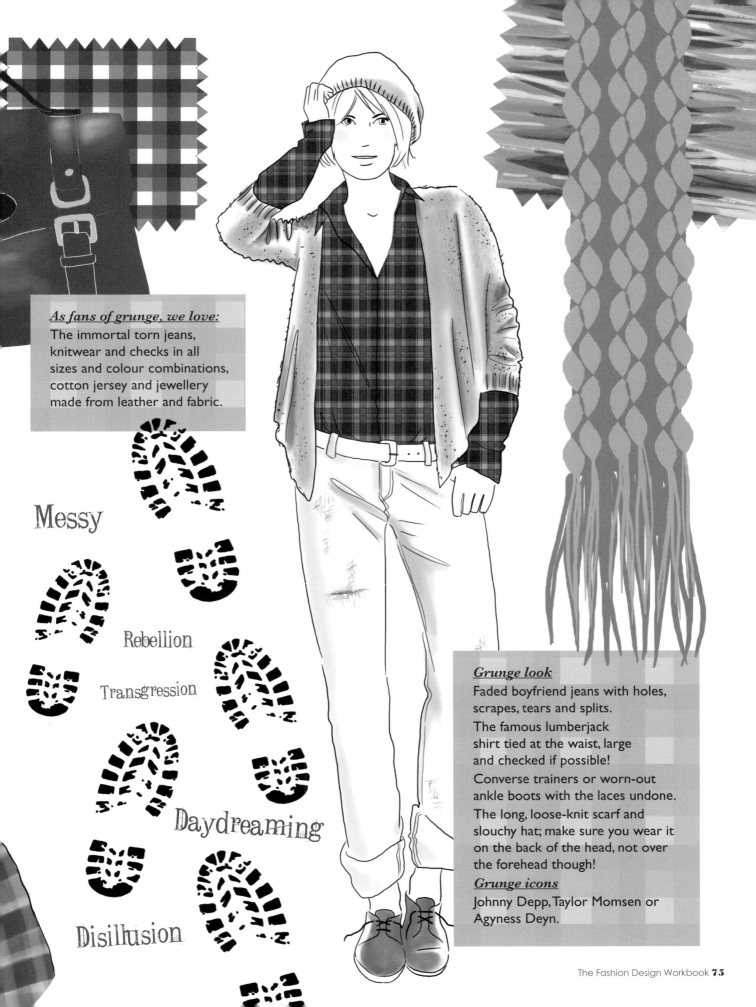

As fans of grunge, we love:
The immortal torn jeans, knitwear and checks in all sizes and colour combinations, cotton jersey and jewellery made from leather and fabric.

Messy

Rebellion

Transgression

Daydreaming

Disillusion

Grunge look
Faded boyfriend jeans with holes, scrapes, tears and splits.
The famous lumberjack shirt tied at the waist, large and checked if possible!
Converse trainers or worn-out ankle boots with the laces undone.
The long, loose-knit scarf and slouchy hat; make sure you wear it on the back of the head, not over the forehead though!
Grunge icons
Johnny Depp, Taylor Momsen or Agyness Deyn.

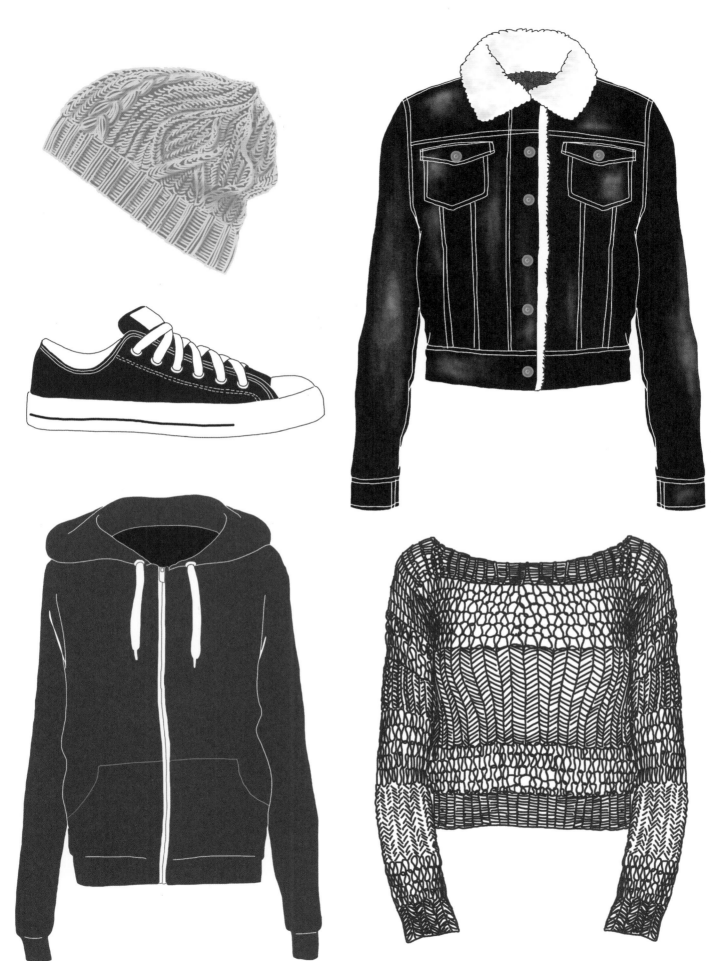

PATTERNS, FABRICS & TECHNIQUES

Tie dye

Checks

Cobain stripes

Fair Isle

1

2

3

4

Knitwear
1. Draw a picture of a stitch.
2. Replicate this drawing to create a line of stitches.
3. Fill in the drawings with colour using felt tip or some paint, leaving a white line of light.
4. Create the 3D effect of the wool with lines in darker coloured pencil.

Lumberjack checks
1. Apply the first colour in horizontal and vertical lines on top of each other in coloured watercolour pencil, paint or ink with some added water to give the effect of transparency.
2. Apply the second colour on top and slightly offset.
3. Apply the third colour, the lightest, on top and slightly offset.

1

2

3

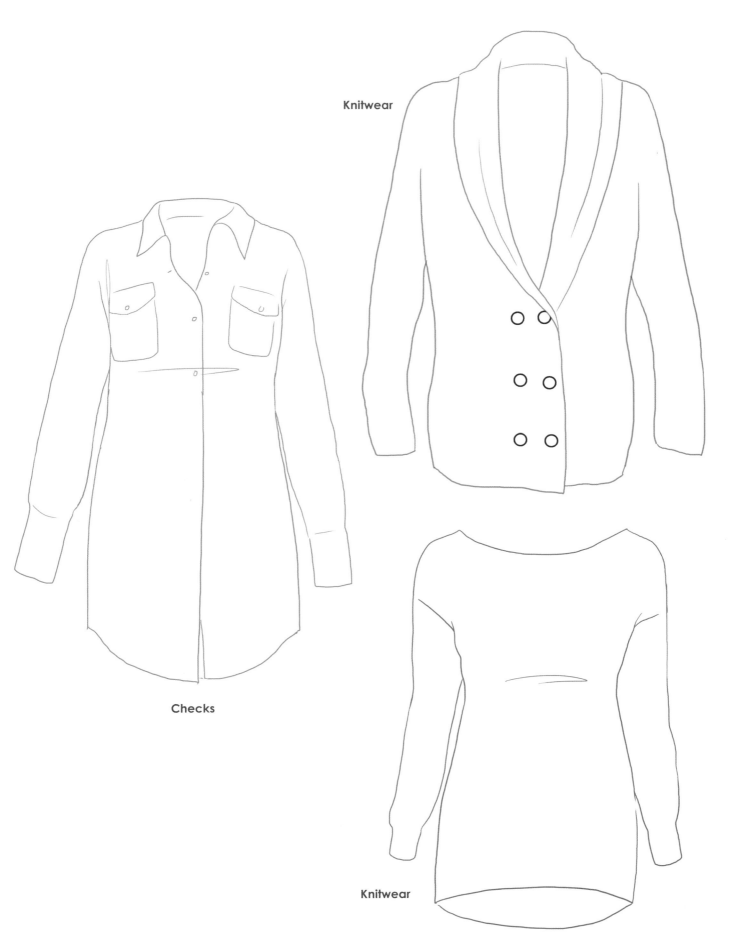

Knitwear

Checks

Knitwear

GRUNGE FASHION FIGURES
TO DRESS AND ACCESSORIZE

VINTAGE

RECYCLED

COUTURE

AUTHENTIC

Essence of vintage

If you enjoy rummaging through your grandmother's cupboards or mooching around car boot sales, markets and vintage clothing shops in search of unique pieces, preferably designer ones that will make the fashionistas green with envy, then you are definitely a fan of vintage style.

Any object that is over 20 years old is considered vintage or retro. However, vintage fashion must be high quality and authentic!

Recycling is good for the planet too! However, you should combine the eras and add your personal touch with a hint of modernity to avoid looking outdated.

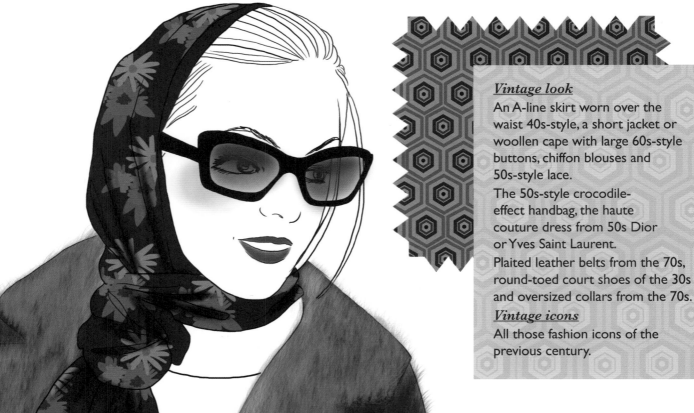

Vintage look

An A-line skirt worn over the waist 40s-style, a short jacket or woollen cape with large 60s-style buttons, chiffon blouses and 50s-style lace.

The 50s-style crocodile-effect handbag, the haute couture dress from 50s Dior or Yves Saint Laurent.

Plaited leather belts from the 70s, round-toed court shoes of the 30s and oversized collars from the 70s.

Vintage icons

All those fashion icons of the previous century.

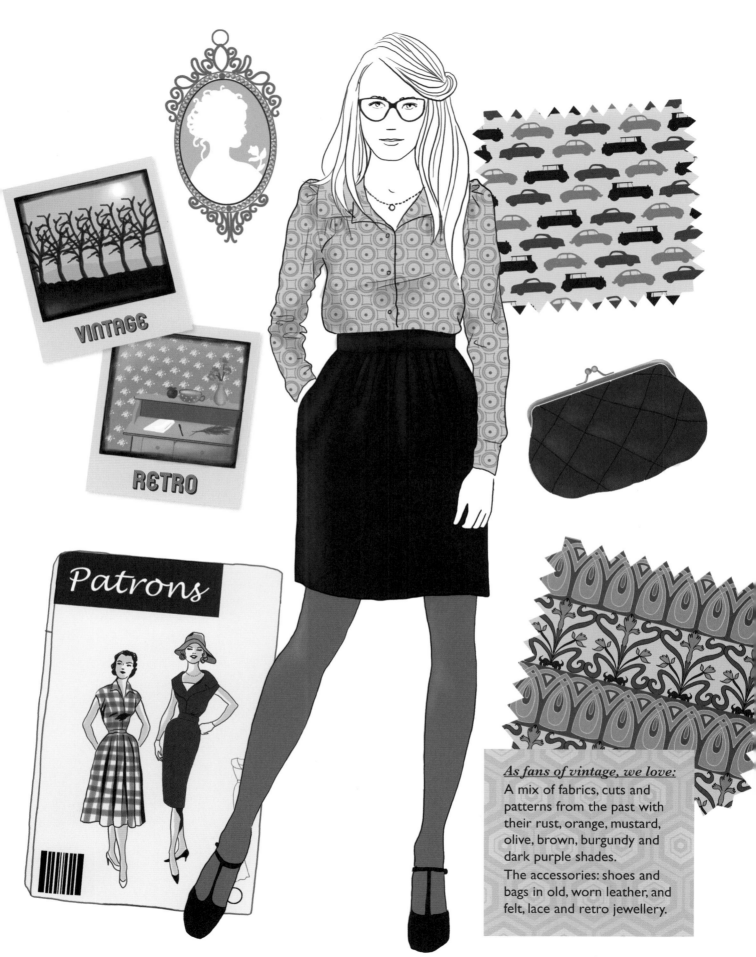

VINTAGE

RETRO

Patrons

As fans of vintage, we love:
A mix of fabrics, cuts and patterns from the past with their rust, orange, mustard, olive, brown, burgundy and dark purple shades.
The accessories: shoes and bags in old, worn leather, and felt, lace and retro jewellery.

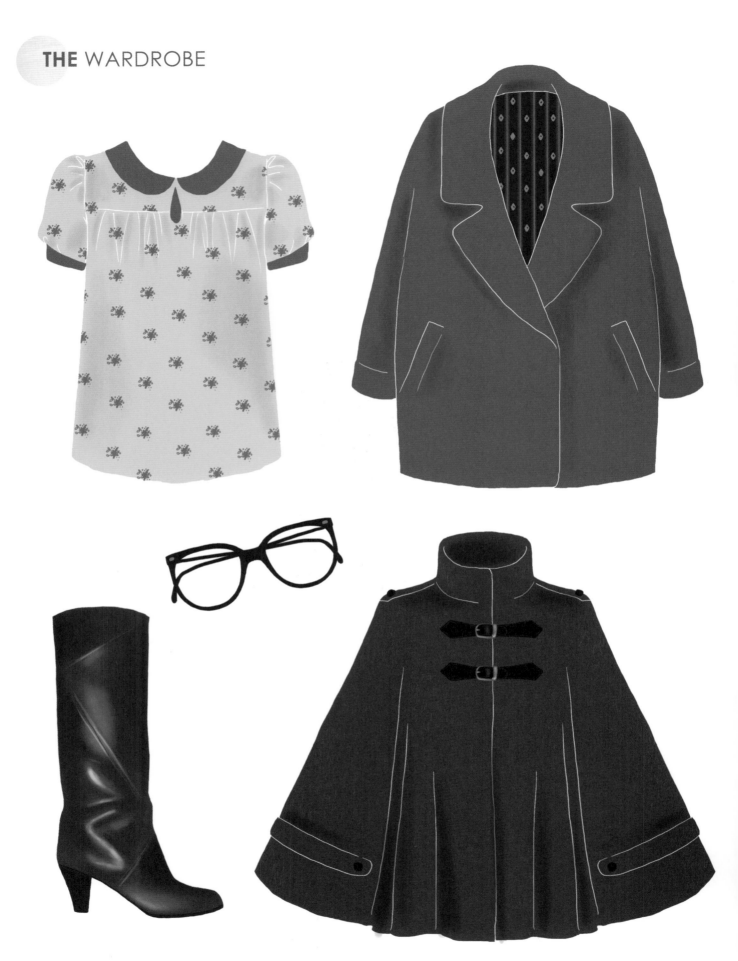

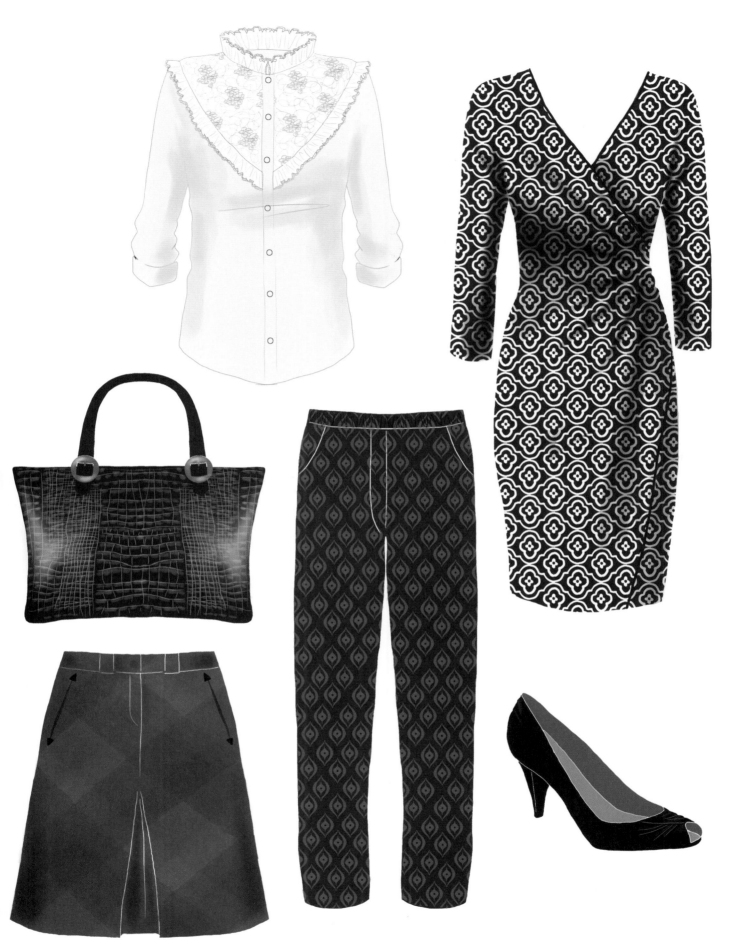

PATTERNS, FABRICS & TECHNIQUES

Retro

Retro

Art nouveau

70s

Psychedelic print

1. Draw various geometric shapes with a pencil.

2. Put the different shapes on top of one another varying their sizes.

3. Colour in the shapes with felt tip, ink or coloured pencil.

4. Repeat these shapes and arrange symmetrically.

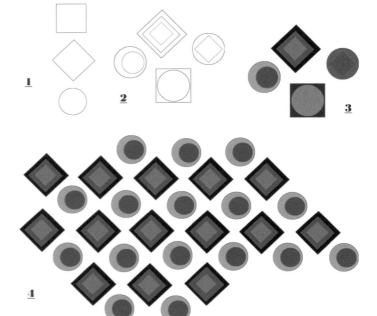

Retro glasses

1. Draw the outline of the left part of the glasses with a pencil.

2. Trace this outline and reproduce it on the right, reversing it, symmetrically.

3. Colour in the glasses with felt tip, ink or coloured pencil, then erase the outline.

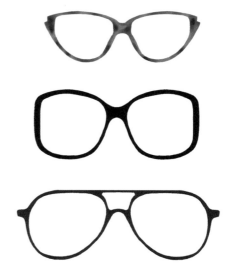

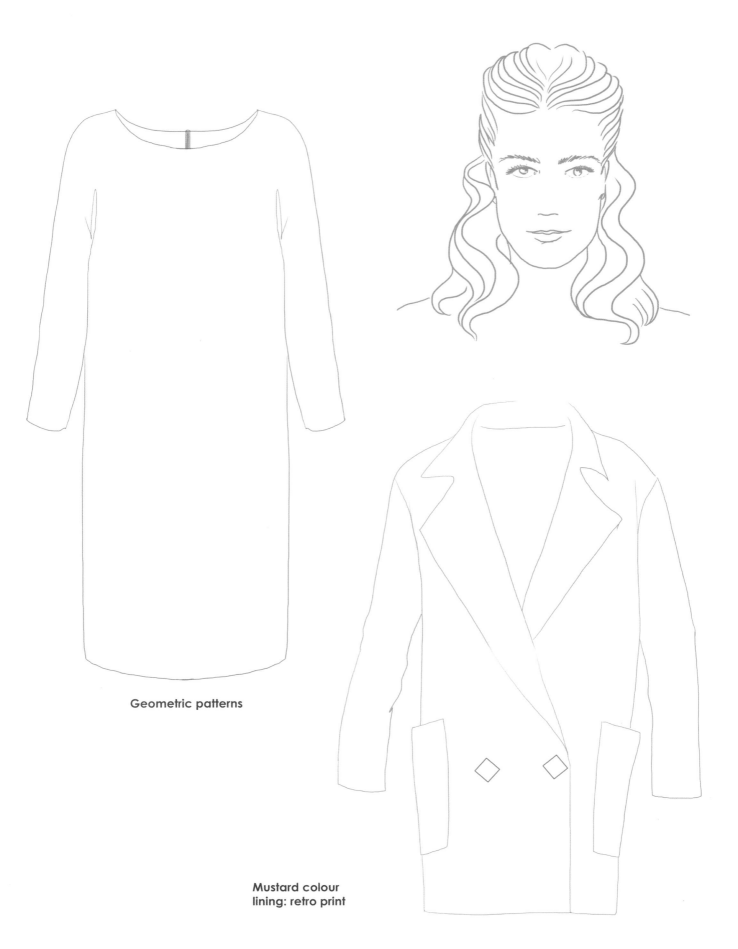

Geometric patterns

**Mustard colour
lining: retro print**

VINTAGE FASHION FIGURES
TO DRESS AND ACCESSORIZE

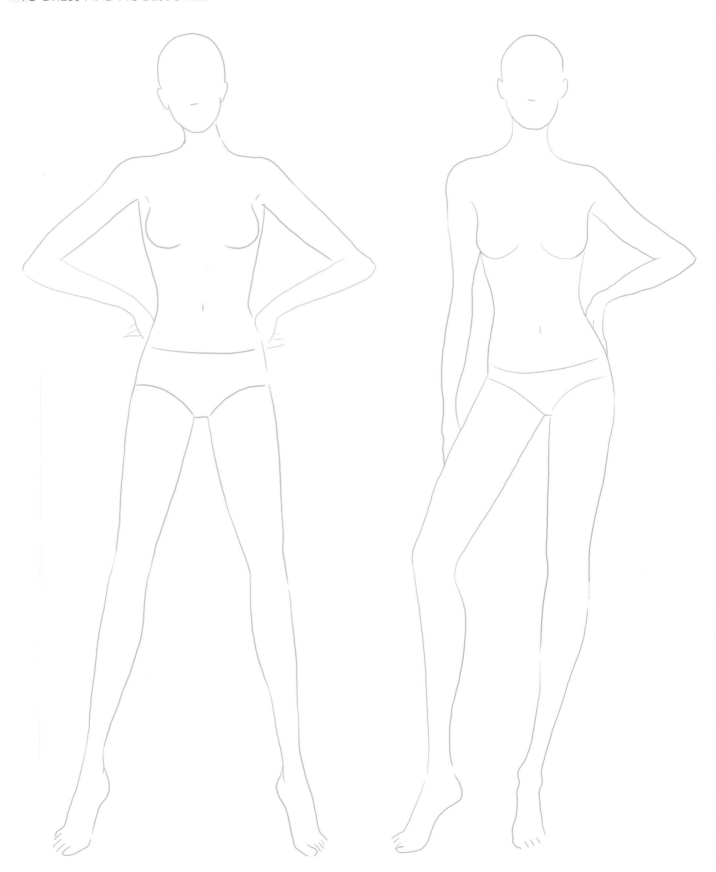

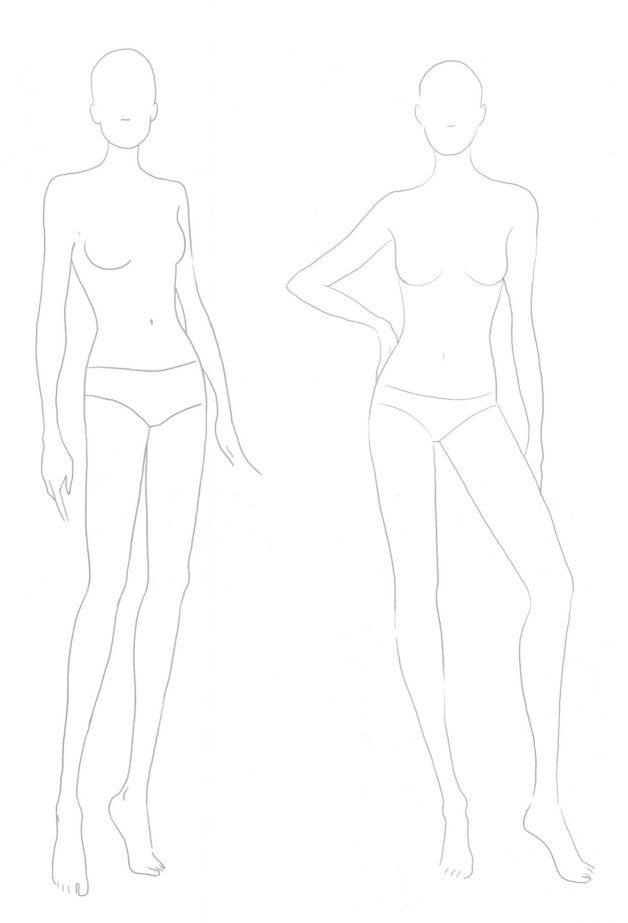

EM★

DEVIATION

Essence of emo

Derived from the hardcore punk movement of the 80s, emo or emocore reflects the expression of broken-hearted feelings, drowned in the tears of painful love and dark melancholy.

It is a melodramatic, androgynous teen fashion, fed and inspired by a mix of punk, rock, hardcore and Goth, peppered with Japanese Manga Trash.

Discover your inner emo and become an emo girl.

WOUND

INTROSPECTION

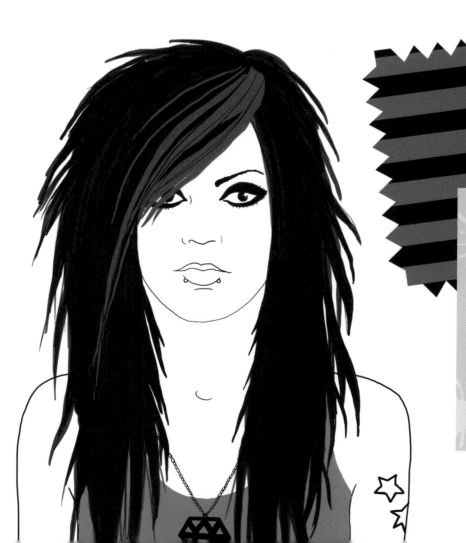

Emo look

Skinny jeans with a zipped hoody and T-shirt with emoticon designs.

Mini-skirts with braces and clips, multi-coloured studded belts and canvas basketball shoes.

'Big hair' and coloured highlights hanging over the eyes, liberal black eyeliner, flashy, punky jewellery and accessories.

Emo icons

The groups Tokio Hotel, The Sounds, Orgy.

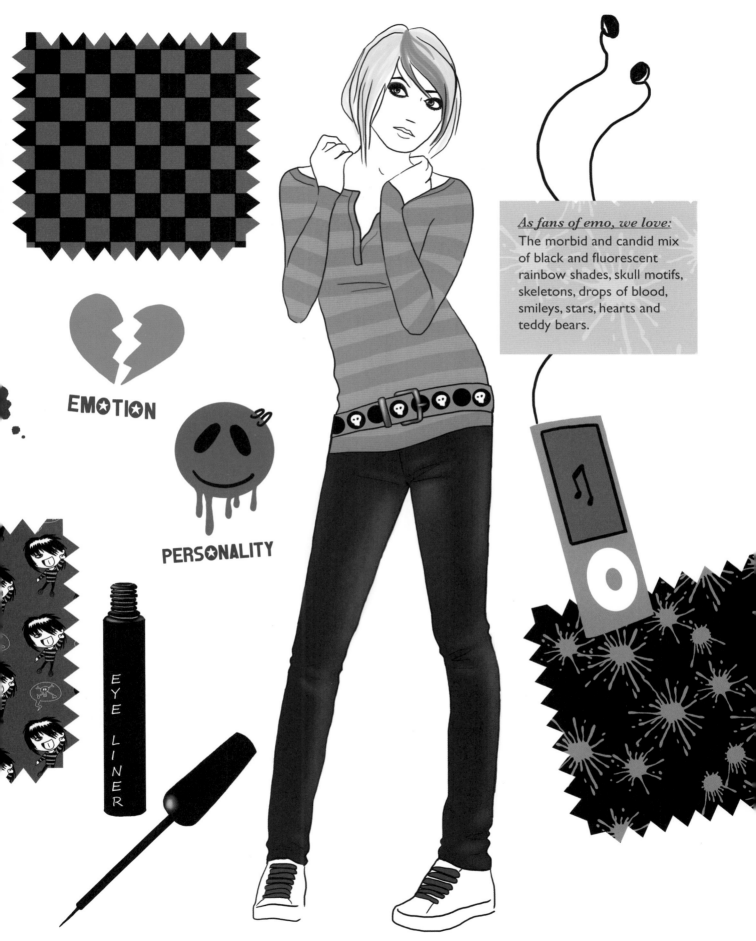

EMOTION

PERSONALITY

EYE LINER

As fans of emo, we love: The morbid and candid mix of black and fluorescent rainbow shades, skull motifs, skeletons, drops of blood, smileys, stars, hearts and teddy bears.

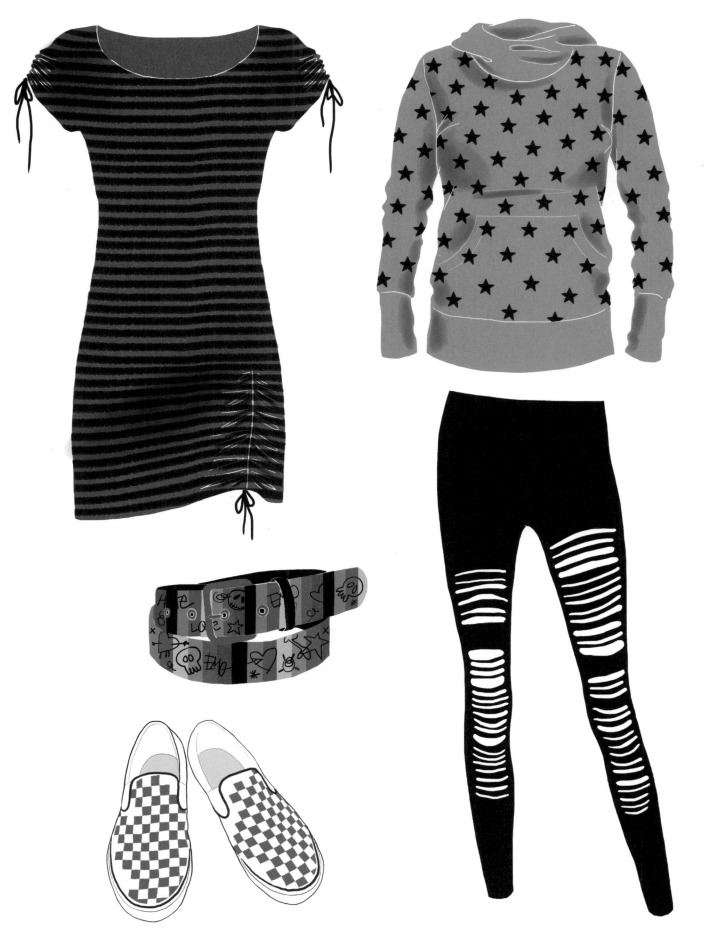

PATTERNS, FABRICS & TECHNIQUES

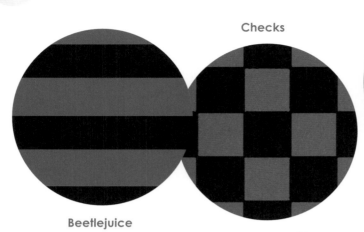

Checks

Beetlejuice

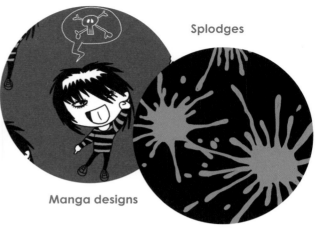

Splodges

Manga designs

2

1

3

Check print
1. Apply a base colour with some paint, ink or felt tip. Once it is dry, draw on a grid with a pencil.

2. Paint every other square in another colour with ink, felt tip or paint.

3. Once it is dry, erase the grid.

Emo eyes
1. Apply black paint or ink mixed with a little water generously around the eyes of your illustrated figure.

2. Outline the eye, adding black ink or paint, building up the layers to make the white inside the eye stand out.

3. Thicken the outline of the eye and lengthen the lashes with a black felt tip pen to give a Manga effect.

1

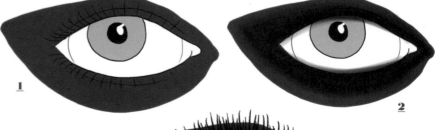

2

3

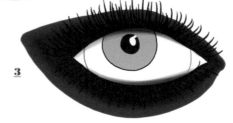

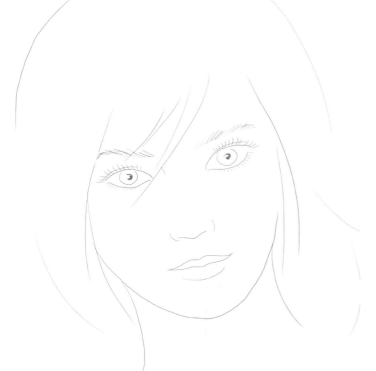

Emo emoticons

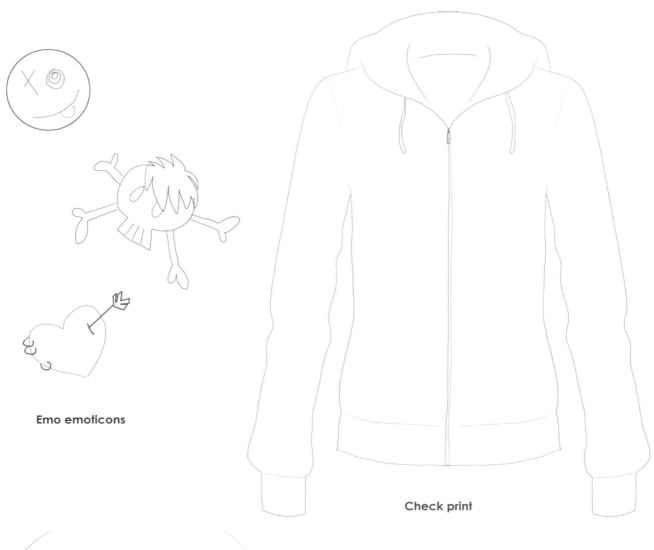

Check print

Emo hairstyle and make-up

EMO FASHION FIGURES
TO DRESS AND ACCESSORIZE

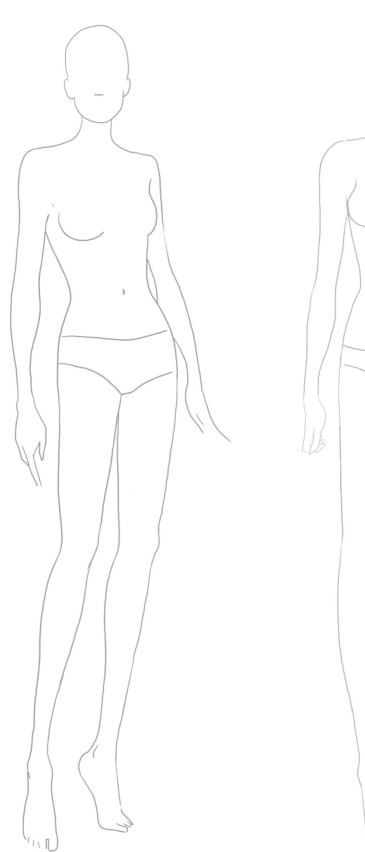

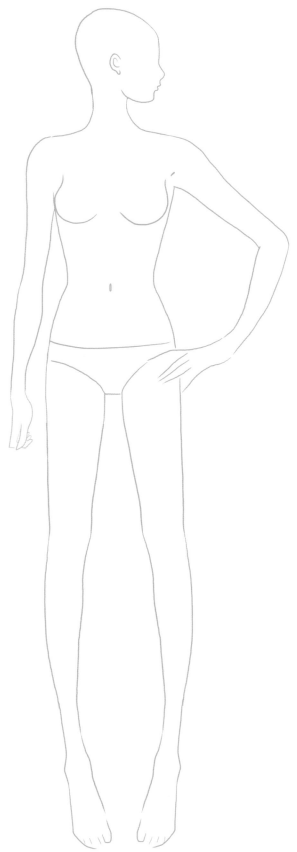

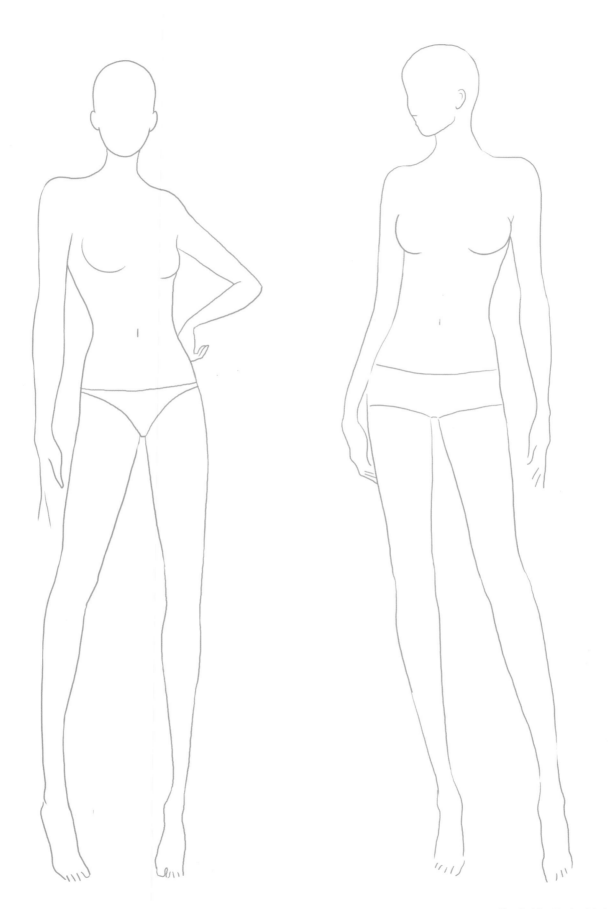

Rockabilly

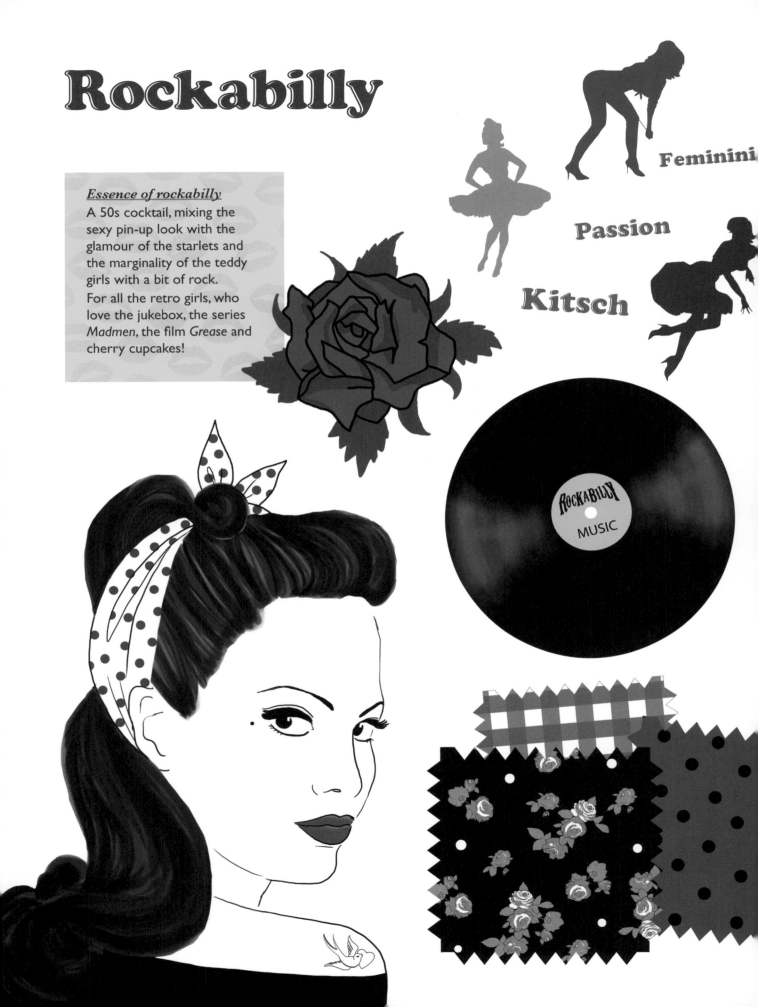

Essence of rockabilly

A 50s cocktail, mixing the sexy pin-up look with the glamour of the starlets and the marginality of the teddy girls with a bit of rock.

For all the retro girls, who love the jukebox, the series *Madmen*, the film *Grease* and cherry cupcakes!

Feminini

Passion

Kitsch

ROCKABILLY
MUSIC

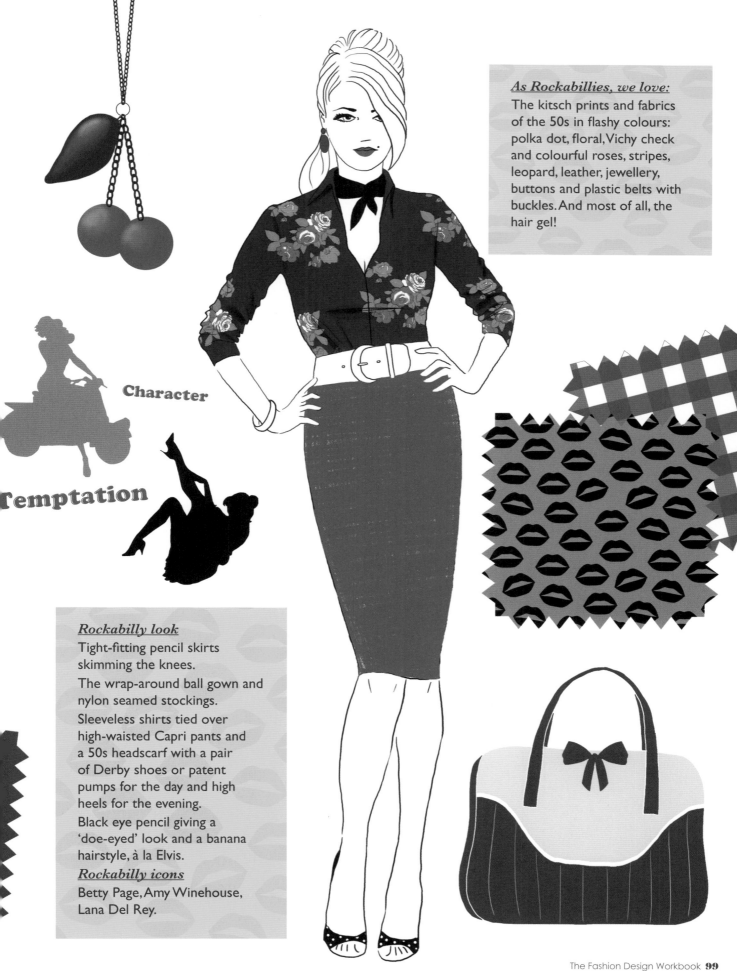

As Rockabillies, we love:
The kitsch prints and fabrics of the 50s in flashy colours: polka dot, floral, Vichy check and colourful roses, stripes, leopard, leather, jewellery, buttons and plastic belts with buckles. And most of all, the hair gel!

Character

Temptation

Rockabilly look
Tight-fitting pencil skirts skimming the knees.

The wrap-around ball gown and nylon seamed stockings.

Sleeveless shirts tied over high-waisted Capri pants and a 50s headscarf with a pair of Derby shoes or patent pumps for the day and high heels for the evening.

Black eye pencil giving a 'doe-eyed' look and a banana hairstyle, à la Elvis.

Rockabilly icons
Betty Page, Amy Winehouse, Lana Del Rey.

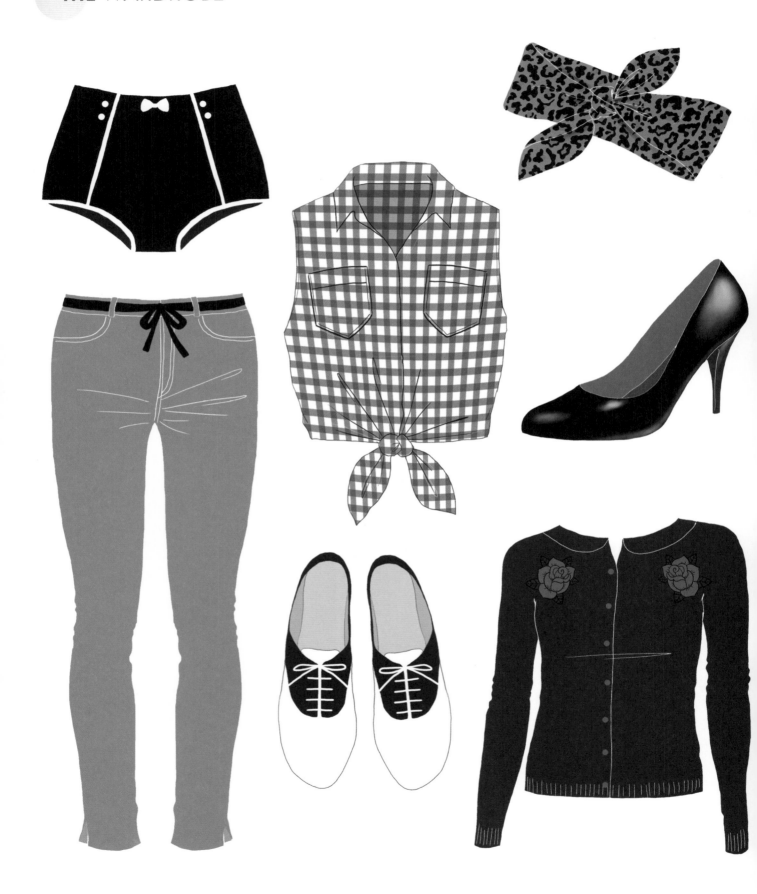

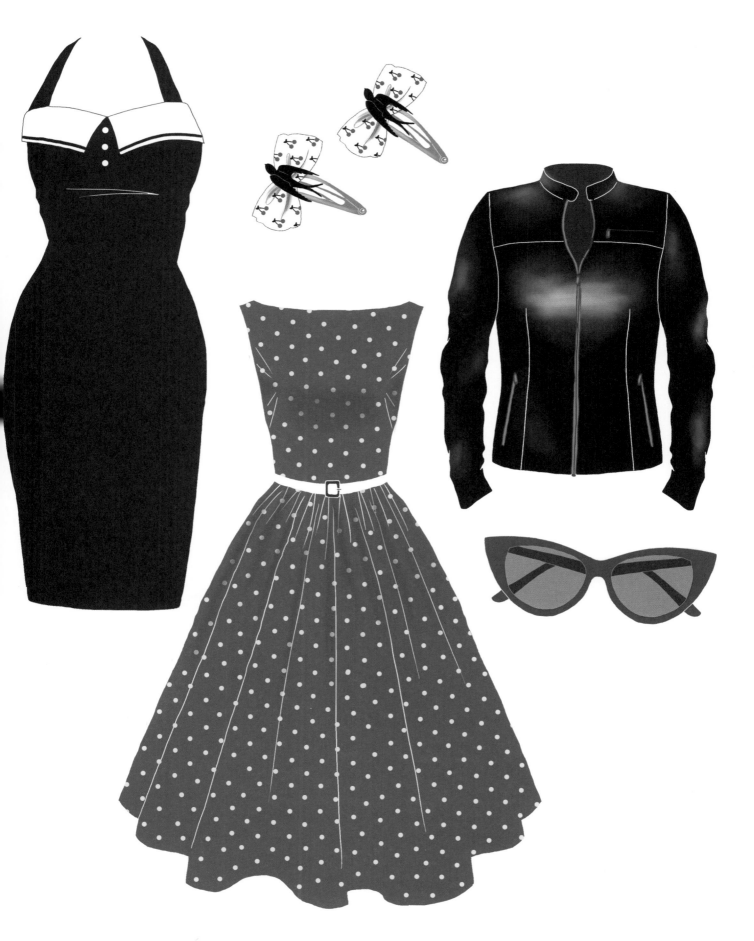

PATTERNS, FABRICS & TECHNIQUES

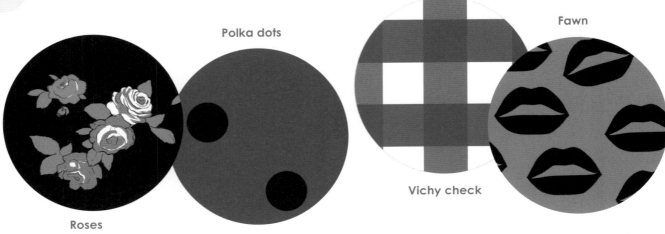

Roses

Polka dots

Vichy check

Fawn

Leopard print

1. Choose a base colour, (paint, ink or felt tip), a fawn colour has been used here in shades of yellow, beige and ochre.

2. With paint, ink or felt tip, make marks using a different colour, but make sure it's similar in shade to the background.

3. Boost the fabric effect by placing random black marks around the marks already made.

1 2 3

Doe-eyed make-up

1. Draw the eyes with a pencil, then go over with black felt tip.

2. Apply a light layer of pencil over the eyelid. Smudge with your finger.

3. Thicken and lengthen the eyelashes with black felt tip to give the effect of volume mascara.

4. Lengthen the gaze with a thick line of black felt tip over the contour of the eyes ending with a flick up towards the eyebrow.

Add a beauty spot in the corner of the eye for more glamour.

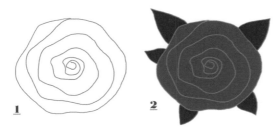

1 2

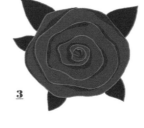

3

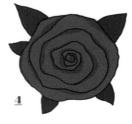

4

Rose

1. To make the outlines of the rose, draw a spiral starting on the outside and working inwards.

2. Fill in with colour using paint, ink or felt tip.

3. Create a 3D effect by applying a darker colour along the petals.

4. Go over the outlines with a thick felt tip pen in black.

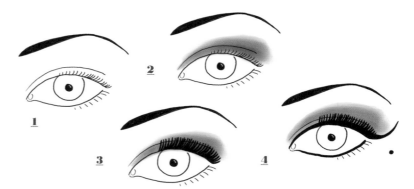

1 2 3 4

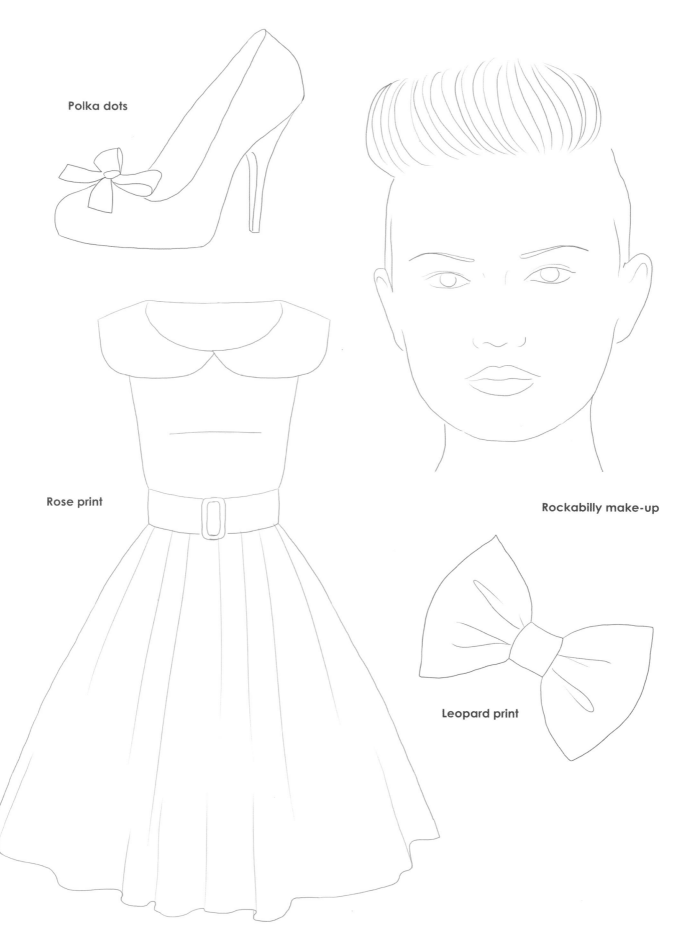

Polka dots

Rose print

Rockabilly make-up

Leopard print

ROCKABILLY FASHION FIGURES
TO DRESS AND ACCESSORIZE

Punk

Essence of punk
No future!
In total opposition to the world of peace and love of the hippie baba cool movement which it followed, punk fashion lashes out, tears apart, insults and refutes the established order, creating a 'destroy attitude' with a credo of 'do it yourself'.

We see razor blades, brushes, scissors, pins and badges. Holes and tears are made and we see customization with the aim of shocking. Punk style conveys the embodiment of provocation, deviation and commitment.

DESTROY

CHAOS

Punk look
A worn, painted, studded biker jacket adorned with badges, a short tartan skirt with a huge safety pin, torn T-shirts with slogans, tight-fitting, torn jeans and a pair of Dr Martens or Creepers. Not forgetting coloured Mohicans and emphasis on black make-up.

Punk icons
Vivienne Westwood, Nina Hagen and Patti Smith.

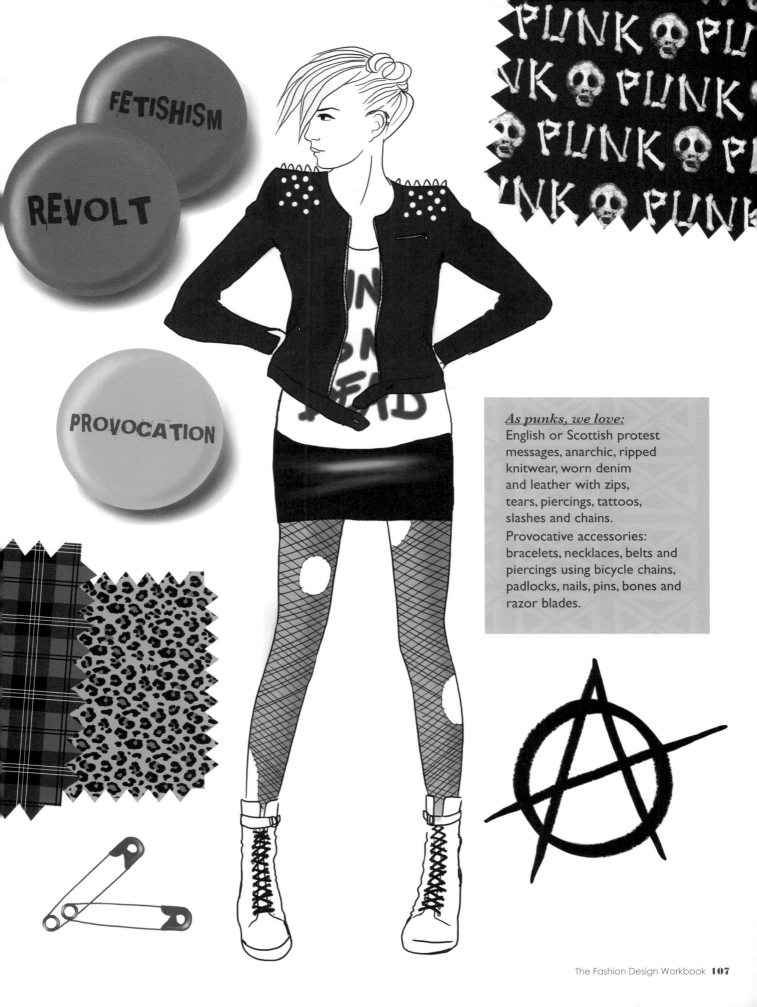

FETISHISM

REVOLT

PROVOCATION

PUNK PUNK VK PUNK PUNK PUNK PINK PUNK

As punks, we love:
English or Scottish protest
messages, anarchic, ripped
knitwear, worn denim
and leather with zips,
tears, piercings, tattoos,
slashes and chains.

Provocative accessories:
bracelets, necklaces, belts and
piercings using bicycle chains,
padlocks, nails, pins, bones and
razor blades.

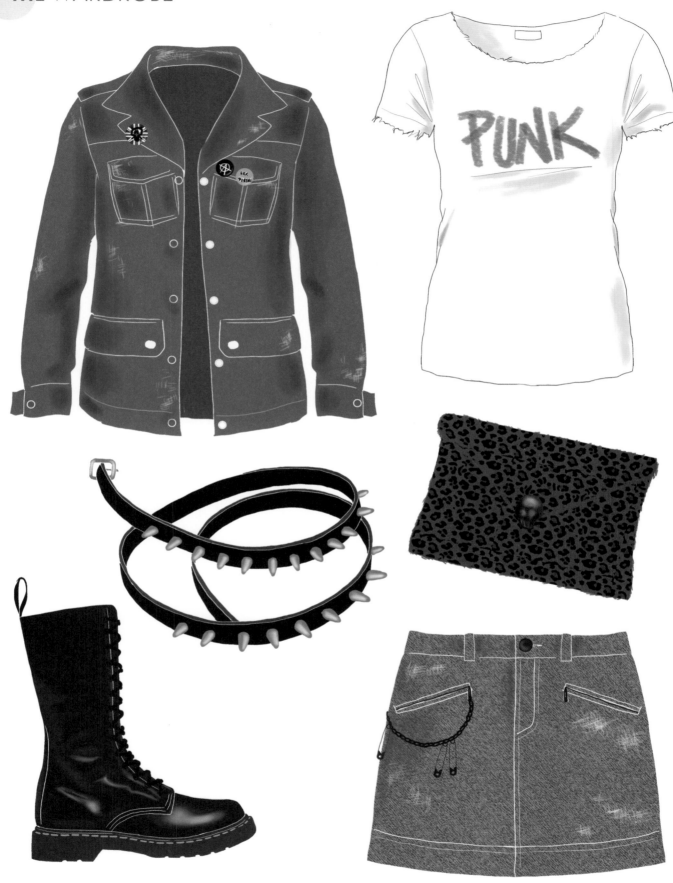

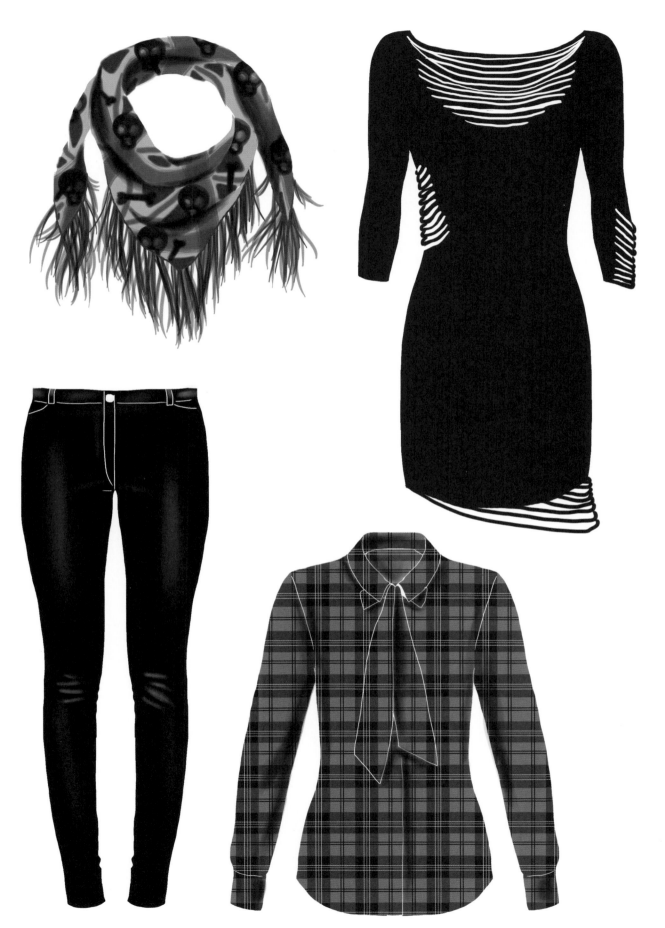

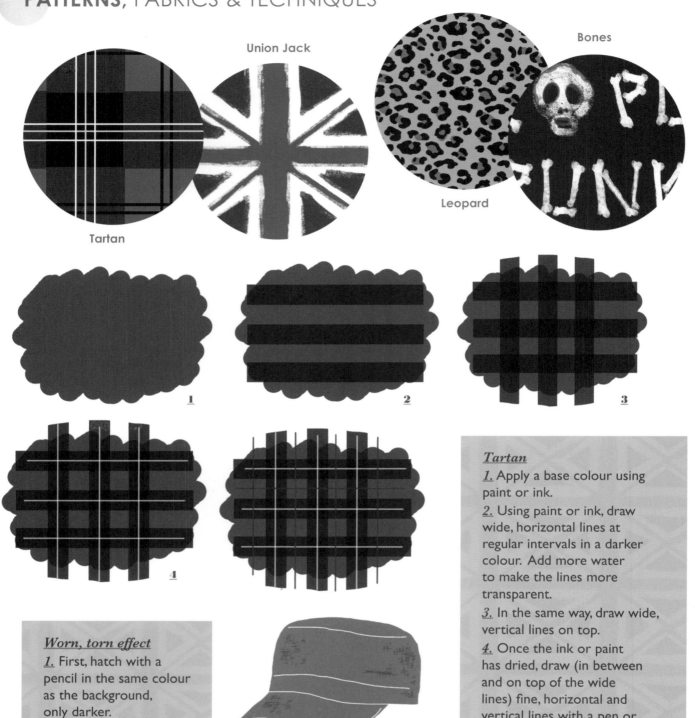

Union Jack

Bones

Leopard

Tartan

1

2

3

4

Worn, torn effect

1. First, hatch with a pencil in the same colour as the background, only darker.

2. Then hatch on top in a white coloured pencil.

1

2

Tartan

1. Apply a base colour using paint or ink.

2. Using paint or ink, draw wide, horizontal lines at regular intervals in a darker colour. Add more water to make the lines more transparent.

3. In the same way, draw wide, vertical lines on top.

4. Once the ink or paint has dried, draw (in between and on top of the wide lines) fine, horizontal and vertical lines with a pen or felt tip in bright colours (white, yellow, blue or red).

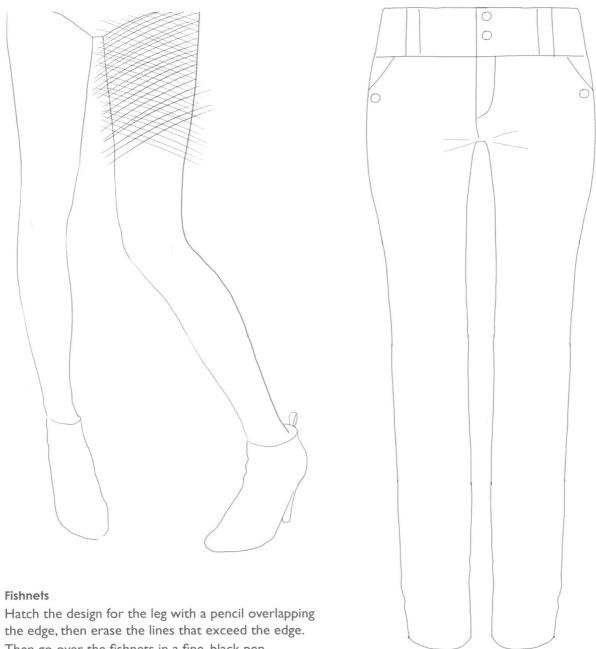

Fishnets

Hatch the design for the leg with a pencil overlapping the edge, then erase the lines that exceed the edge. Then go over the fishnets in a fine, black pen.

Tartan print

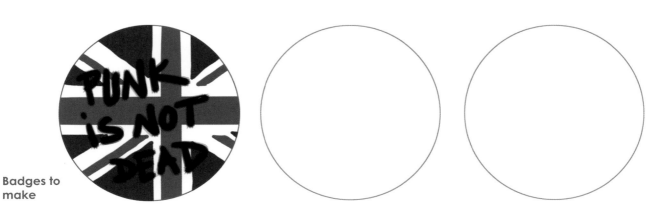

Badges to make

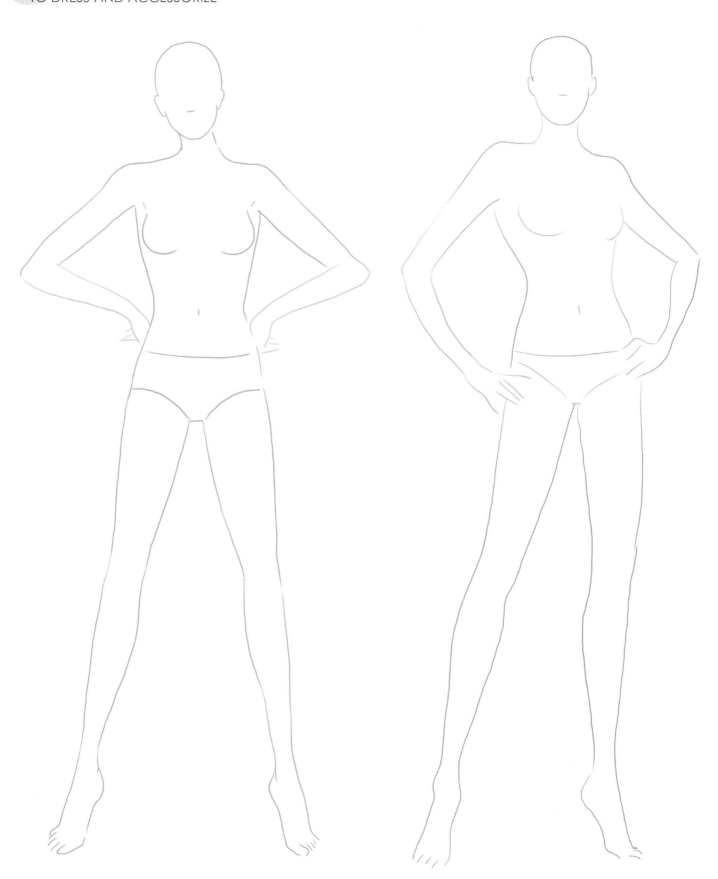

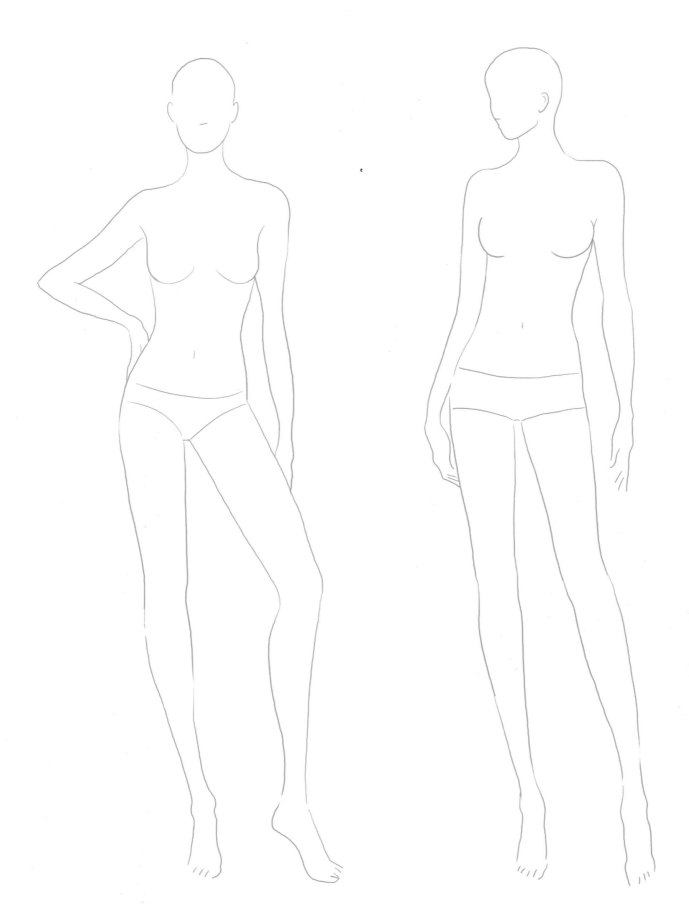

Goth

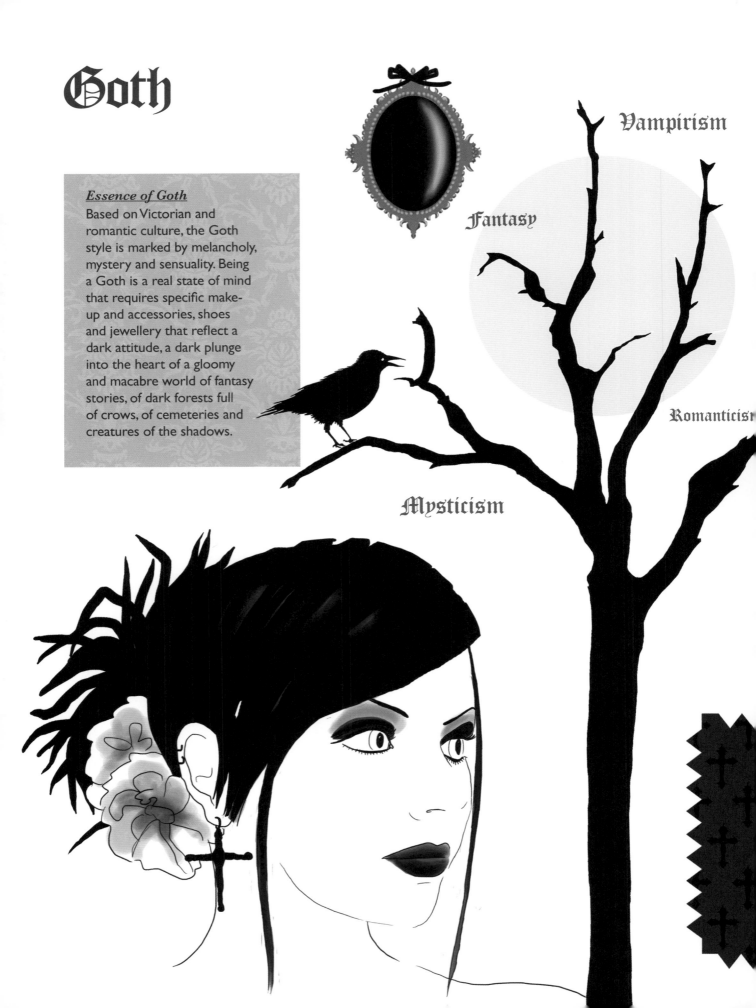

Vampirism

Fantasy

Essence of Goth
Based on Victorian and romantic culture, the Goth style is marked by melancholy, mystery and sensuality. Being a Goth is a real state of mind that requires specific make-up and accessories, shoes and jewellery that reflect a dark attitude, a dark plunge into the heart of a gloomy and macabre world of fantasy stories, of dark forests full of crows, of cemeteries and creatures of the shadows.

Romanticism

Mysticism

Melancholy

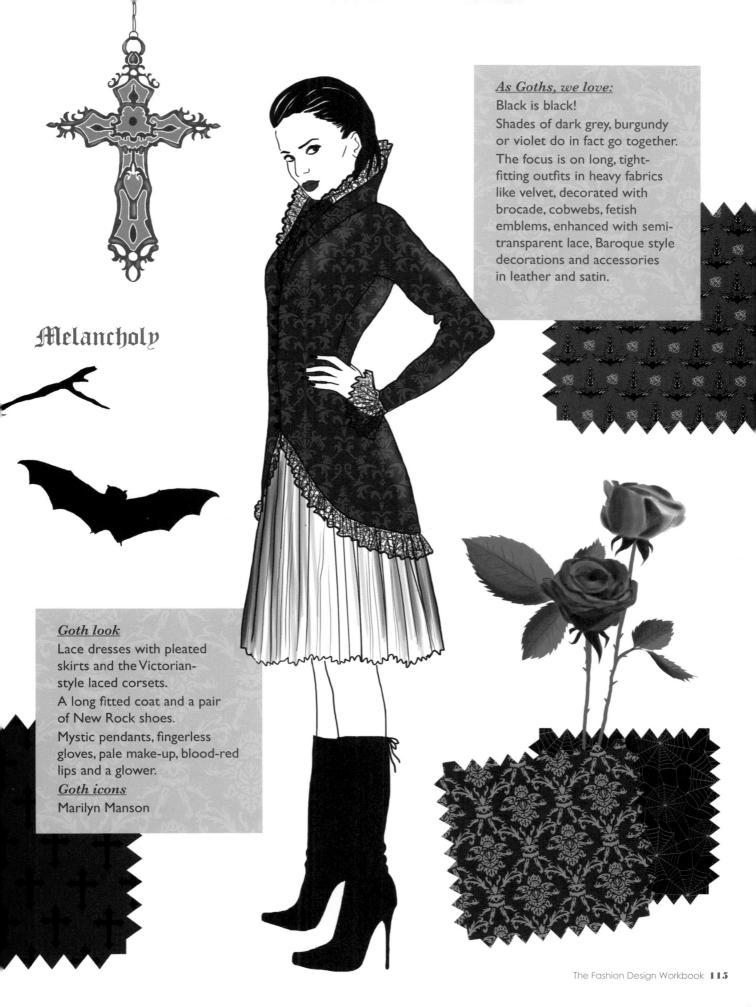

As Goths, _we love:_
Black is black!
Shades of dark grey, burgundy or violet do in fact go together.
The focus is on long, tight-fitting outfits in heavy fabrics like velvet, decorated with brocade, cobwebs, fetish emblems, enhanced with semi-transparent lace, Baroque style decorations and accessories in leather and satin.

Goth look
Lace dresses with pleated skirts and the Victorian-style laced corsets.
A long fitted coat and a pair of New Rock shoes.
Mystic pendants, fingerless gloves, pale make-up, blood-red lips and a glower.
Goth icons
Marilyn Manson

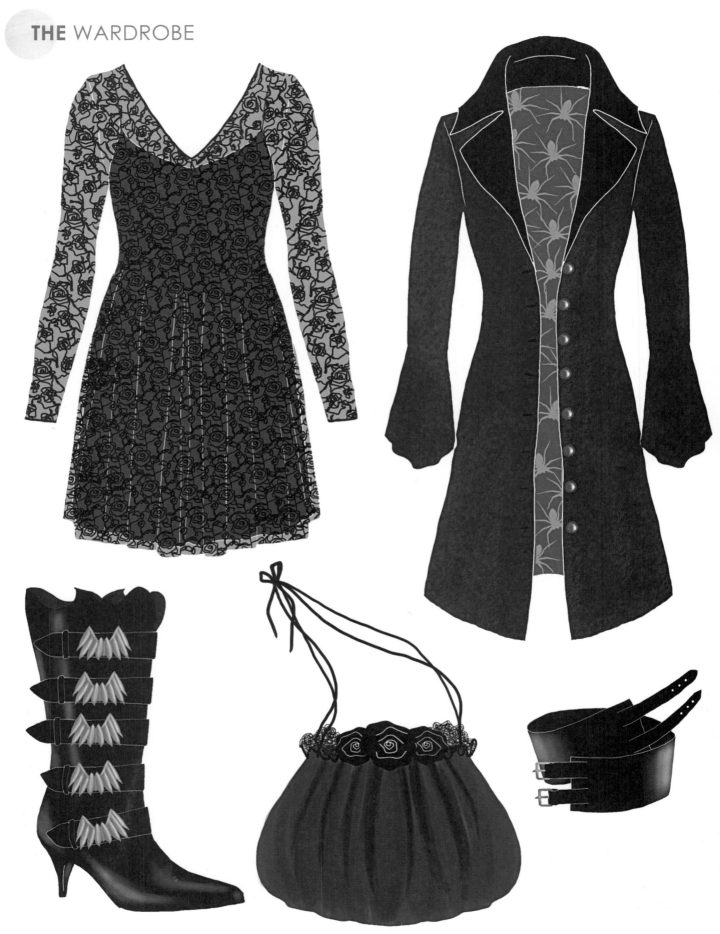

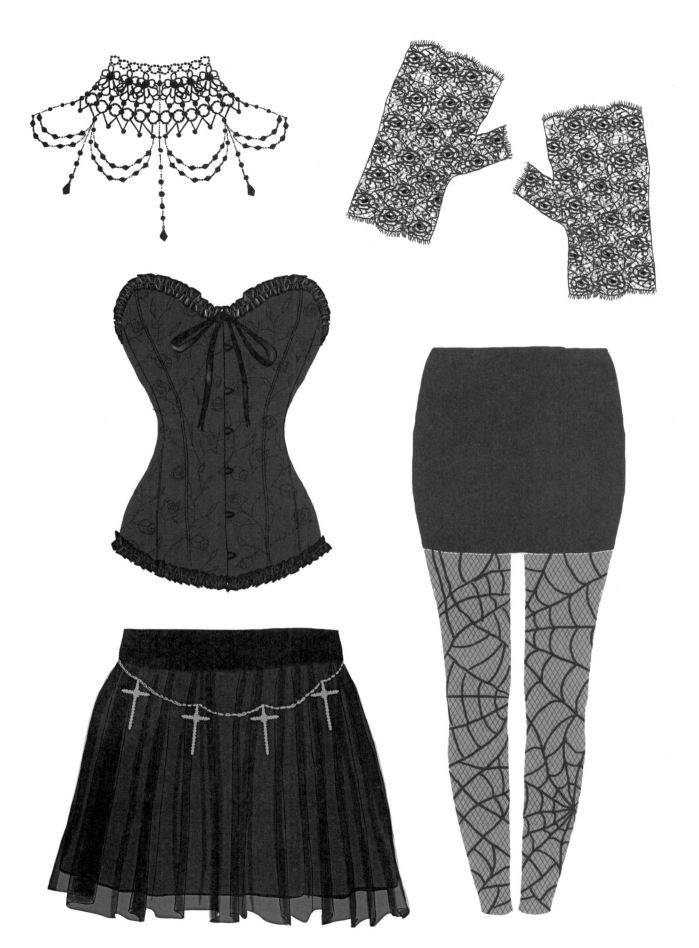

PATTERNS, FABRICS & TECHNIQUES

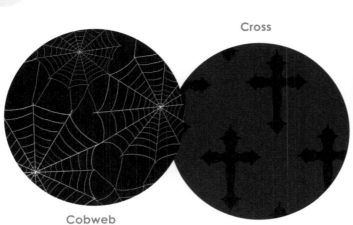

Cobweb

Cross

Victorian

Tribal

Cobweb

1. Draw the base in pencil, pen or felt tip: draw several lines, like strands that all cross at the same point.

2. Weave the web by joining these strands up with each other using slightly curved lines from the centre to the outside.

3. To create a cobweb print, reproduce several webs that are joined together with random strands.

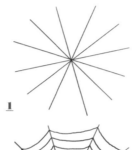

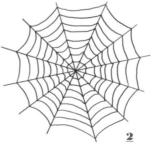

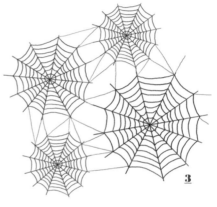

Victorian lace

1. Draw a lace pattern in pencil. The one here is of a thorny rose.

2. Trace the pattern and reproduce several times on an area of lace, overlapping the edges.

3. Erase the lace that overlaps the area.

4. Go over the patterns with a fine pen or felt tip in black.

5. Apply black ink or paint to the area with a lot of water to achieve the transparent effect of the lace.

6. You can draw a simpler lace pattern for the small areas, such as the frill on the fingerless gloves. Just draw scribbles in fine pen or felt tip in black, scattered with black dots.

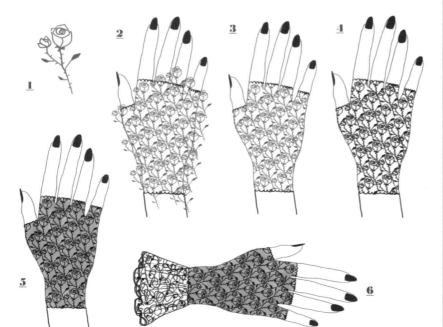

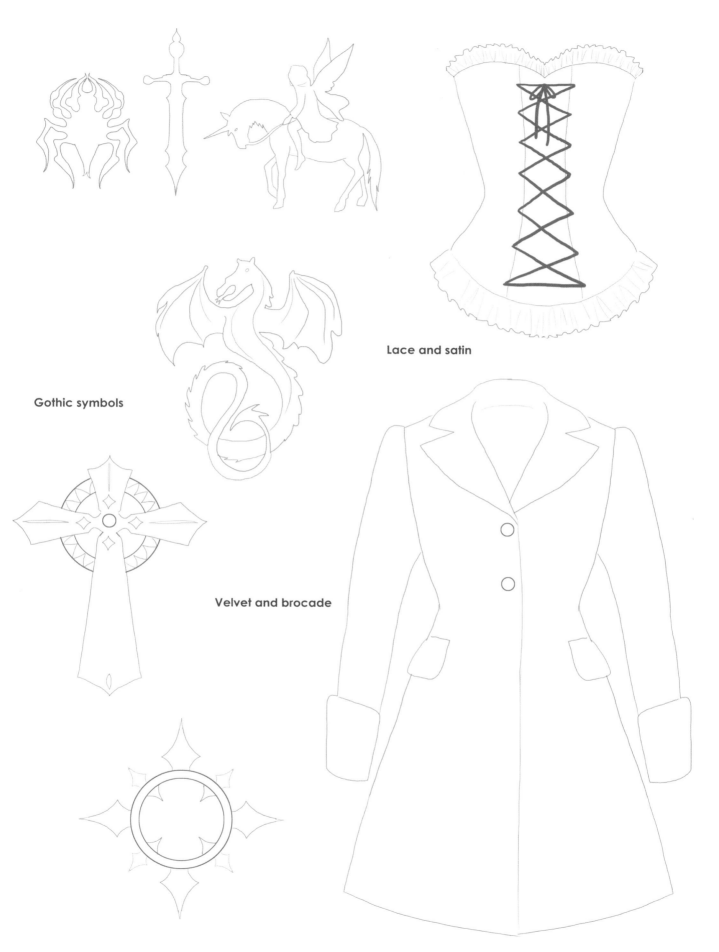

Lace and satin

Gothic symbols

Velvet and brocade

GOTH FASHION FIGURES
TO DRESS AND ACCESSORIZE

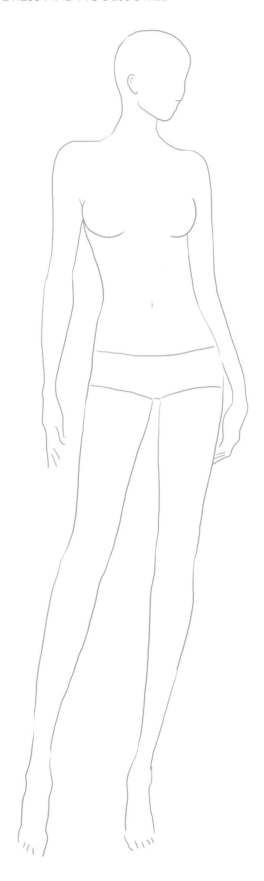

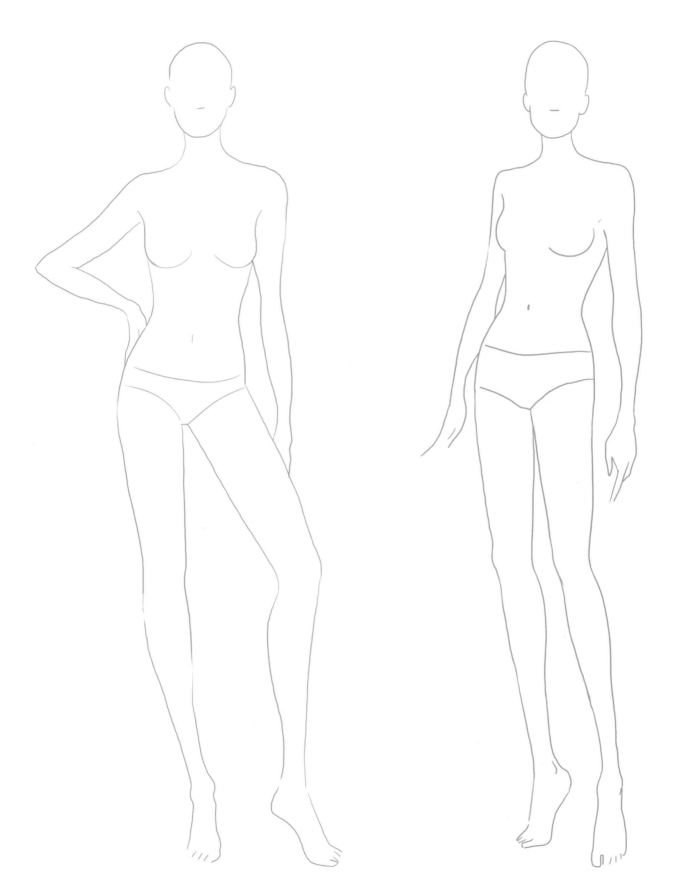

EXAMPLES OF COMBINED STYLES

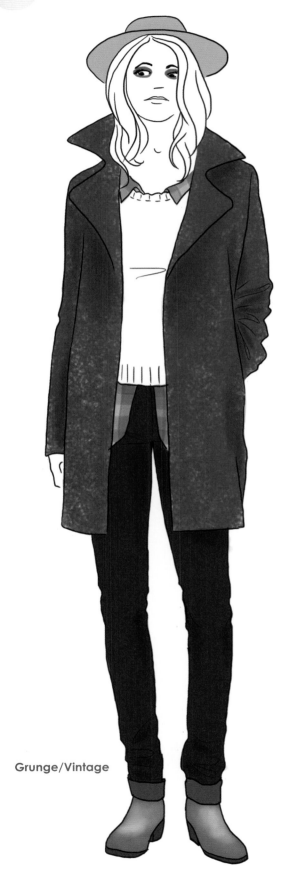

Grunge/Vintage

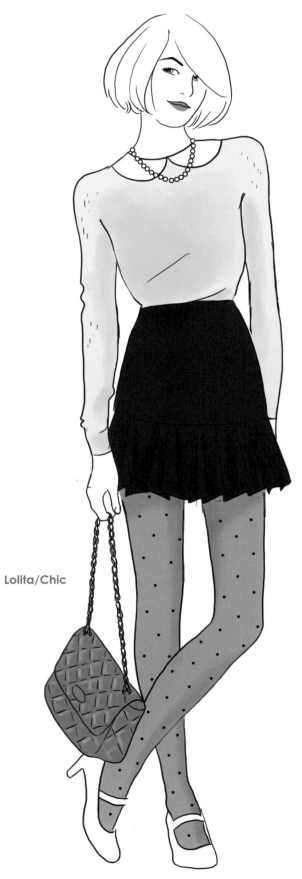

Lolita/Chic

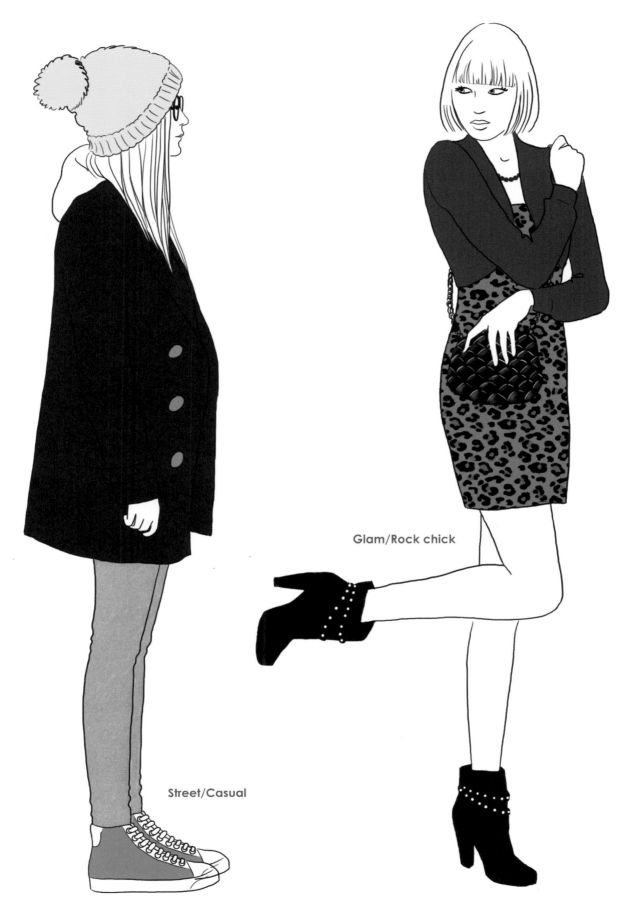

Street/Casual

Glam/Rock chick

Chic/Rockabilly

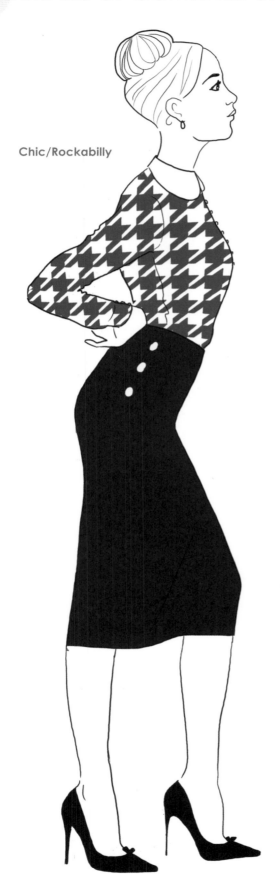

Goth/Lolita

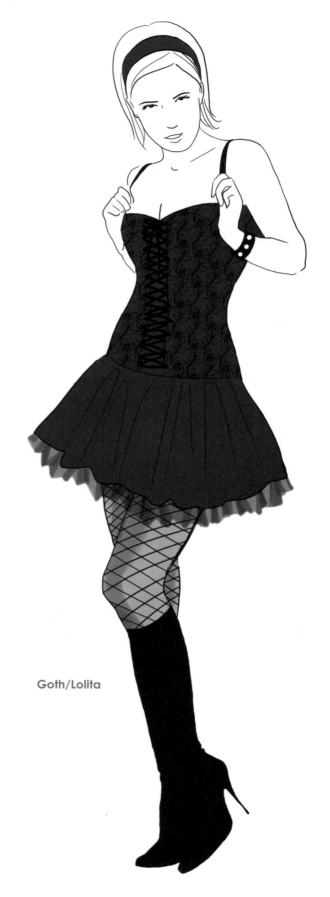

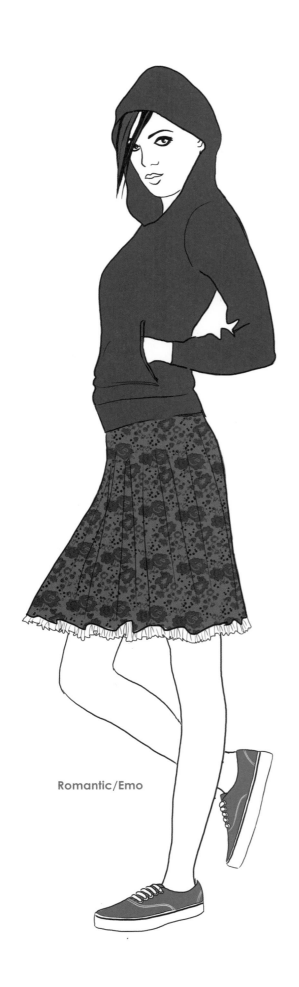

Romantic/Emo

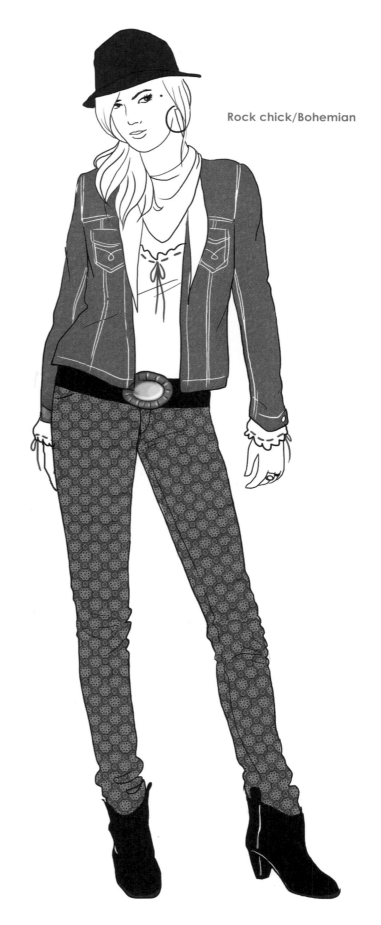

Rock chick/Bohemian

EXAMPLES OF COMBINED STYLES

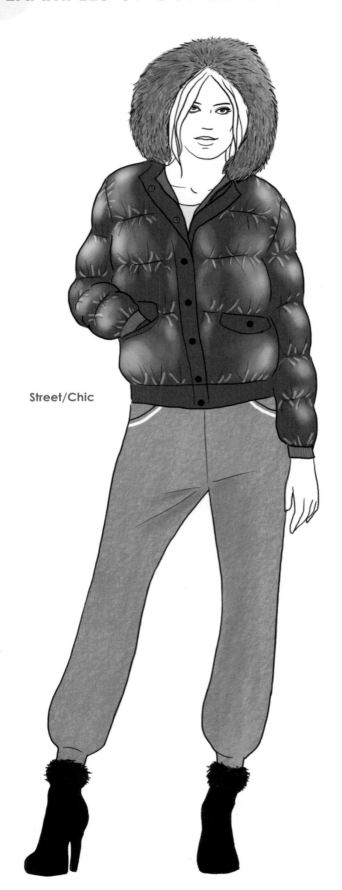

Street/Chic

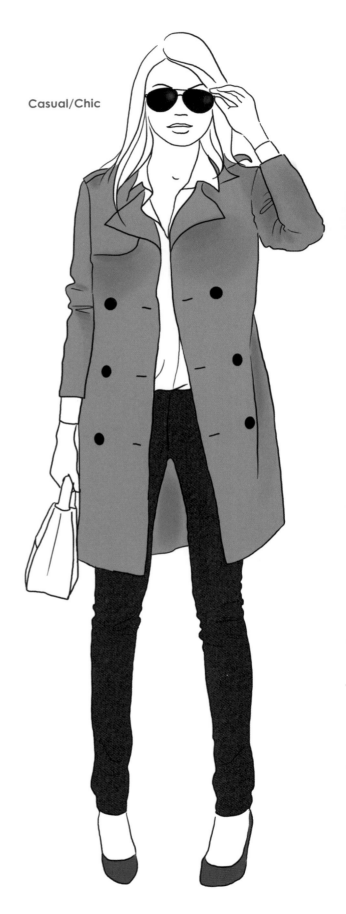

Casual/Chic

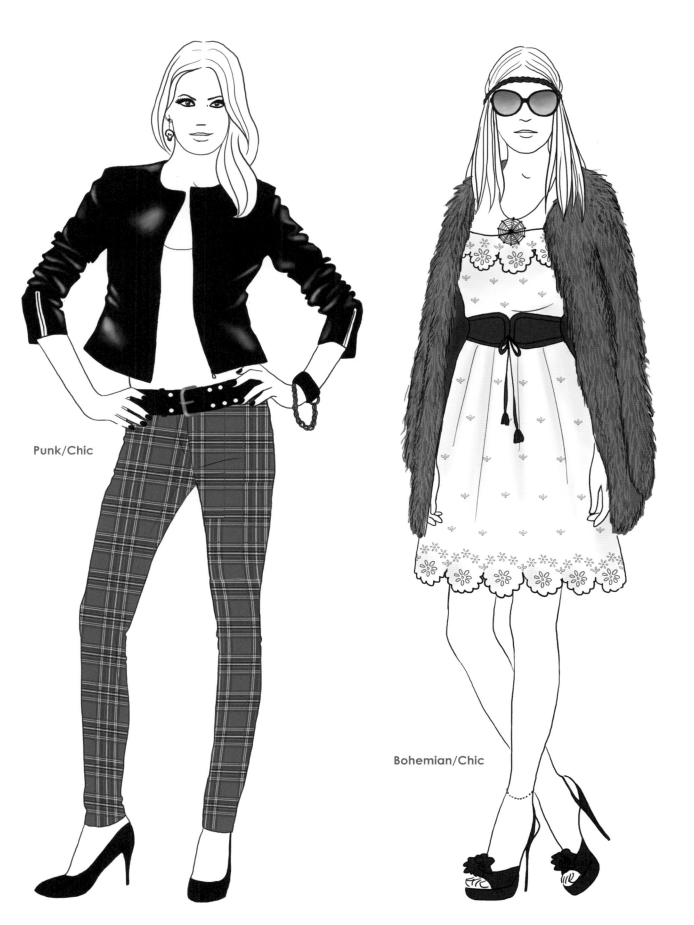

Punk/Chic

Bohemian/Chic

A DAVID & CHARLES BOOK
© Dessain et Tolra/Larousse 2013
Originally published as Cahier de Styles à Dessiner

First published in the UK and USA in 2014 by F&W Media International, Ltd
David & Charles is an imprint of F&W Media International, Ltd
Brunel House, Forde Close, Newton Abbot, TQ12 4PU, UK

F&W Media International, Ltd is a subsidiary of F+W Media, Inc
10151 Carver Road, Suite #200, Blue Ash, OH 45242, USA

A catalogue record for this book is available from the British Library.

ISBN-13: 978-1-4463-0491-4 paperback
ISBN-10: 1-4463-0491-4 paperback

Printed in China by RR Donnelley for:
F&W Media International, Ltd
Brunel House, Forde Close, Newton Abbot, TQ12 4PU, UK

10 9 8 7 6 5 4 3 2 1

Head of publishing: Colette Hanicotte
Editorial coordination: Corinne de Montalembert and Emma Gardner
Graphic design and layout: Violette Benilan
Cover: Angélique Noyelle and Jennifer Stanley
Proofreading – editing: Chantal Pagès and Freya Dangerfield
Production: Marie-Laure Vaillé and Beverley Richardson
Photoengraving: Irilys

F+W Media publishes high quality books on a wide range of subjects.
For more great book ideas visit: www.stitchcraftcreate.co.uk